IMAGES
of America

PORTLAND'S
WOODLAWN
NEIGHBORHOOD

ON THE COVER: The tracks for the streetcar are headed east up then-named Columbia Avenue, now named Dekum Street. The streetcar tracks went to Twenty-fourth Street, approximately one mile. (Courtesy Oregon Historical Society, CN 001560.)

IMAGES
of America

PORTLAND'S
WOODLAWN
NEIGHBORHOOD

Anjala Ehelebe

ARCADIA
PUBLISHING

Published by Arcadia Publishing
Charleston, South Carolina

Printed in the United States of America

Library of Congress Catalog Card Number: 2007930842

For all general information contact Arcadia Publishing at:
Telephone 843-853-2070
Fax 843-853-0044
E-mail sales@arcadiapublishing.com
For customer service and orders:
Toll-Free 1-888-313-2665

Visit us on the Internet at www.arcadiapublishing.com

This is dedicated to my friends and neighbors in Woodlawn who provided stories and images, and to my husband, Lee, who provided encouragement, support, and wise counsel. Also to the hundreds of Parent-Teacher Association members, Woodlawn School teachers, and Woodlawn Neighborhood Association volunteers who have made Woodlawn the special place it is today.

CONTENTS

ACKNOWLEDGMENTS

Thanks to Martha Burnett and her aunt Hilda Erickson who provided vivid descriptions of life on unpaved Oneonta Street and in early Woodlawn. Thanks so much to Sean Lusby, Thelma Diggs, Ethan Jewett, and Sharon Flegal for last-minute crucial photographic and historical materials. Thanks to the librarians at Multnomah County Library for their research and assistance, both virtual and physical, that helped me find the Historical Resource Inventory (HRI) photographs. The staff at the Oregon Historical Society (OHS) gave many excellent tips and had rare books and articles that made the research fascinating. Ted Hoff gave me a copy of and permission to quote from his highly amusing and often suspenseful book on growing up in Woodlawn, *Why Is Your Cow in My Living Room?* Don Porth of the Portland Fire Bureau vividly brought turn of the century firefighting techniques and habitations to life. Richard Thompson generously shared his train lore and photographs. Terry Grigsby provided delightful information about the many past uses of the building and business his grandfather purchased, father Walter remodeled, and that Terry now runs. Diana Banning and Brian K. Johnson from the Stanley Parr Archives and Records Center (SPARC) helped me find and scanned in many of the images used here. Jan Clutter provided the photographs of the buildings of Woodlawn Park. Also thanks to Conrad Hurdle and his grandmother Ernestine Brame, to Carolyn Brown, Celesta Paul, and Lee Martin for providing information, supportive actions, and services. Unless otherwise noted, all pictures are courtesy of the author's collection.

INTRODUCTION

The donation land claim owned by William McClung touched another owned by Lewis Love and a third parcel of bounty land owned by David Ulery. Each had their own plans for their parcels, and joining together to develop a town was not one of them. They were scraping by in a very rural, timber-based economy. Lewis Love had claims both in Vancouver, Washington, and in Oregon. He died a very wealthy man in 1903. McClung and Ulery sold their portions.

It took three ambitious men, Dekum, Durham, and Stratton, to envision the city to be. First they formed the Oregon Land and Investment Company (OLIC). They had plans to run what became the Portland and Vancouver Railway Company through this remote area four miles northeast of downtown Portland. Since the major roads were dirt, Oregon rain created much mud, and cars sank axle-deep when it rained. Train travel on tracks above that mud was preferred. Portland is situated where two rivers join: the mighty Columbia, flowing east to west, and the Willamette, flowing south to north. After bridges across the Willamette developed in the early 20th century, commercial areas developed along streetcar routes, and new subdivisions were planned nearby. Irvington, Woodlawn, and Piedmont neighborhoods were promoted as streetcar suburbs.

The oldest settled part of the Albina area is the Woodlawn Historic District. Initially settled in the 1860s as a rural farming village not called Woodlawn, it was the only independent town that existed outside the city of Albina. Woodlawn's character changed dramatically in 1888 when the railroad running from Portland to Vancouver located a train station in the center of the village. This connection to a larger market stimulated development. The commercial uses centered around the train station with residential development surrounding it. The depot was located at the intersection of today's Durham Avenue and Dekum Street. The station's waiting room was built in the middle of a triangular park.

In 1889, the OLIC planned the town of Woodlawn. The railroad curved to go from what was then called Fourth Street over to Eighth Street, and then rolled over trestles to Hayden Island in the Columbia River. From there, ferries took travelers to Vancouver, Washington. The planning engineers made the streets angled to match the railroad path. Fourth Street, which the train ran along, later became Union Avenue and later yet, Martin Luther King Jr. Boulevard. In 1891, the City of Albina annexed everything north of it to Columbia Boulevard. Then, also in 1891, Portland, East Portland, and Albina were consolidated into Portland, and many streets had to be renumbered and renamed. Albina was an independent river town on the swampy east side of the river before its consolidation with the city of Portland.

Across the road (Fourth Street) from Woodlawn in Piedmont neighborhood, advertisements promoted it as Portland's first high-quality, strictly residential neighborhood: "Piedmont (the Emerald) Portland's Evergreen Suburb, Devoted Exclusively to Dwellings—a Place of Homes." Since no businesses were permitted in Piedmont, commercial trade occurred in Woodlawn, especially along Fourth Street. A shoe repair, a butcher, a baker, a confectioner, a fuel provider, a doctor; you name it, Woodlawn had it. Both Woodlawn and Piedmont are on a bluff that runs

parallel to the Columbia River. A realtor's advertisement around the beginning of the 20th century noted the following:

"Its location is such that a view is afforded out over that splendid waterway and beyond the slopes northward to Mount Saint Helens, which stands with a perpetual covering of snow and sends the inspiration of its grandeur to the beholder day after day, year after year: one never tires of its serene beauty. Mount Hood and Mount Adams are also in view from this splendid residence tract."

Since that was written, Mount St. Helens marred its serene beauty by volcanically exploding.

In 1894, the city of Portland (what we call downtown Portland today) was flooded by the Willamette River, and water covered 250 or more city blocks. This shows another virtue of building houses and businesses on a bluff. In the 1920s, paved major roads, the improved automobile, and a bridge between Vancouver and Portland gave residents more shopping options, and businesses in Woodlawn were either swept aside for housing or converted to factories. Nowadays Woodlawn is 15 minutes by car to Washington State, 10 minutes to the Portland International Airport, 15 minutes to downtown Portland, and 15 minutes to excellent shopping malls (slower at rush hours). Woodlawn is well served by buses, and freight trains glide by at the base of the bluff. Some residents move here because they love the sight and sound of trains. Many residents commute by bicycle to their jobs. The airport sometimes has planes taking off and landing over this and nearby neighborhoods (depending on wind direction), and that has become an issue taken up by neighborhood associations.

Atop the bluff, Woodlawn is mostly residential, with Queen Anne–style houses, craftsman bungalows, and an influx of modern infill housing and condominiums. Woodlawn has a potential historic district based on a number of well-preserved houses. Some of those homes are occupied by families who have lived in Woodlawn for six generations. In the 1940s and 1950s, many ranch and smaller homes were built throughout the neighborhood to house the working-class residents and evacuees of the 1948 Vanport Flood (this time the Columbia River flooded). Many of the Vanport people had worked in the shipyards during World War II, and some were African American. Integration happened in Woodlawn very smoothly. Property values were depressed in the 1990s and, until recently, houses were affordable. Today Woodlawn maintains a diverse population, as young families, older residents, renters and home buyers, white, black, Hispanic, and Pacific Island residents, are noted in recent census records. Woodlawn in the 21st century has fascinating businesses and unique landmarks. Light and heavy industrial businesses flank the current train route, as do a variety of businesses that need space, such as plant nurseries. Two miles of Ainsworth Street, mostly within the Woodlawn and King neighborhoods, form a unique linear arboretum. In the last two years, there has been a revitalization of businesses along Dekum Street, as envisioned in the 1993 Woodlawn Plan.

By the 1970s, the housing stock was in decline and the Federal Model Cities programs made available millions of dollars for improving neighborhoods. The parent-teacher association at Woodlawn School was the first one organized in Oregon. They wrote the first Woodlawn Plan in 1963, and PTA activists formed the nucleus of later neighborhood association leaders. The Woodlawn Improvement Association spearheaded projects such as the razing of 80 houses to build Woodlawn Park. In the 1990s, gang and crime issues caused the Woodlawn Neighborhood Association (WNA) to band together and work with authorities to improve the situation. Now Woodlawn is reaping the benefits of the actions of our activist fore-neighbors. We have hosted major city bike races (1995), the Oregon Symphony played a summer concert in Woodlawn Park (2005), and in 2007, we celebrated the extremely rainy but well-attended citywide Earth Day in Woodlawn Park.

One

THE CREATION OF WOODLAWN

The triangular block in the center of the map, just below the railroad track, is where the firehouse was built. The street the train followed was renamed from Scott to Madrona Street, and then Madrona (south of Columbia Boulevard) became Seventh Avenue. When the trolley came into town, it followed the train line but did not curve. It went east out to Fourth Avenue on what was then called Columbia Avenue and is now Dekum Street. The street was named after Frank Dekum, a former California gold rush prospector, starter of Portland's first bakery and confectionary shop, "Dekum & Bickel, Manufacturers and Importers of American, German and French Confectionery." (Courtesy of City of Portland.)

This image from the deed record book shows the undeveloped area, noted as "40," that was probably developed in 1890 as the Woodlawn Yards at Madrona Street. The train went north over trestles to the Columbia River, ending on Hayden Island. A ferry from Vancouver would land on Hayden Island to take the passengers the rest of the way. (Courtesy Keith Gannon.)

This illustration of Fort Vancouver shows how sparsely settled, rural, and agricultural settlements of the 1880s were. Timber was cut and burned to clear spaces for housing. Lewis Love, whose land claims became parts of Woodlawn (see the northwest corner of the map above), saw profit to be made from waste, and thrifty ingenuity made him a millionaire. (Courtesy University of Washington Libraries, Special Collection, NA4171.)

The trolley that came into Woodlawn was abbreviated the WL line for Wood Lawn. Later it became part of the Williams Avenue trolley bus line. This shows WL 472 with George S. Race and Carleton E. Walker at the end of the line. (Courtesy Richard Thompson.)

This is trolley number 45 in the Woodlawn Yards. Notice the lovely patterns on the seats because they were carpeted, and note as well as the advertisements affixed to the ceilings above the seats. (Courtesy Richard Thompson.)

This is WL car number 333 in downtown Portland, c. 1908. In 1900, service began from downtown Portland to East Eighth and Dekum Street. In 1912, the line was extended to Thirteenth Street, and from May 1913 until the end of service the outer end of the line was at Twenty-fourth Street N and Dekum Street. (Courtesy Richard Thompson.)

Here we see WL car number 45 heading for the Barn. The former Portland Railway unit is being used as a streetcar. That's a snow sweeper to the right. (Courtesy Richard Thompson.)

WL 331 on Dekum Street is stopped in front of a water tower. (Courtesy Richard Thompson.)

This trolley derailed on June 21, 1903, near the Burnside Bridge and a couple of women were bruised. Luckily a telephone pole stopped it from sliding into the water. After the streetcar era, trolleys were burned or abandoned. One trolley car was abandoned in front of Woodlawn's Grigsby Brothers Paper Box company. It was later donated to the Council Crest neighborhood. (Courtesy Richard Thompson.)

This photograph looks east and shows a train loaded with lumber and grain in the front few cars, heading toward the majestic Mount Hood. The Amalgamated Sugar silo is to the left in the middle distance. This stretch of tracks was re-laid in 2006. This was taken from Martin Luther King Jr. Boulevard on a busy overpass. (Courtesy Miles Hochstein of Portland Ground.)

This shot is looking west down Lombard Street toward Martin Luther King Boulevard. To the right is a tall white silo that stores sugar brought in by some of the trains. On the extreme right side of the previous picture are houses on the slope of the bluff. This shot has those houses showing on the left side.

Two

WOODLAWN ODD FELLOWS HALL

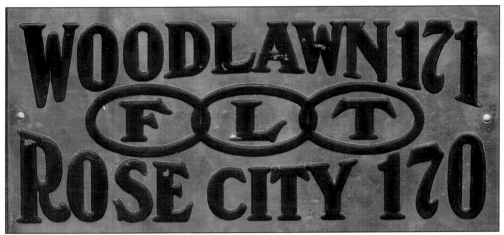

This brass nameplate adorned the Woodlawn Odd Fellows Hall, which for decades was the social center of the town. "Woodlawn Hall [was] not only used by the members but was also the scene of meetings for neighborhood scout troops, women's groups and bingo clubs. They put on potlucks, held bingo games, craft, and bake sales. Activities of all sizes and shapes reverberated through the old, heavily varnished hall nearly every night of the week" (from *Why Is Your Cow in My Living Room?* by Ted Hoff). Near the hall, there used to be a tavern—not the Tam O'Shanty that quietly celebrated the art of pool sharking. Locals say most of the big-name pool sharks in the United States came here to try their skills against other sharks. Terry Grigsby says he recalls Minnesota Fats played there. The pool hall burned down mysteriously and was not rebuilt.

Grand Lodge of Oregon

I. O. O. F.

THOS. F. RYAN, GRAND MASTER

ROOMS 2 AND 3, MASONIC TEMPLE

OREGON CITY, OREGON

December 20, 1910.

To the Officers and Members of Subordinate Lodges:

BRETHREN—As the year 1910 draws to a close, I send you fraternal greetings, and trust that you will enter upon the New Year with the determination, that your Lodge during the year 1911 "will fail in nothing for which it was instituted."

I am pleased to state, that after visiting a large percentage of the Lodges in the jurisdiction, I believe that the year that is passing away has been one of great prosperity to our Order, and find every indication that 1911 will be the banner year of our organization in Oregon.

Let us never forget that the success of our Order depends upon each one of us who entered into that solemn compact to, not only, "visit the sick, relieve the distressed, bury the dead and educate the orphan" but also assist in elevating and upbuilding character, that character that is the foundation of every great nation, the salvation of every true man.

Let us pause a few moments, and each take a farewell look backward through the sunshine and the shadows of the passing year, and see if we cannot there find light and inspiration, to make a more successful and still greater effort, to exemplify in our daily life the sublime principles which we teach; let us be more friendly, more social, more fraternal in our lodge meetings; more conscientious in our daily work; more kindly affectionate with our loved ones at home; more thoughtful and active and earnest in our visits to and care of our brethren who are sick or suffering; do these things a little more earnestly and well during the coming year, and most satisfactory will be the result.

In my visits throughout the State, I have been impressed with the thought, that the great need of the hour is that we be brought closer together in our lodge affiliations, so that we may engage more unitedly in our work and thus keep FRIENDSHIP, that splendid link of our Order, true, strong and bright; this I believe can be brought about more fully and completely by each and every Lodge having, at least once a year what might be called a "HOME DAY MEETING" to which every member would receive a special invitation to attend, or if he be far away and impossible for him to be there in person, that he be requested to send his written greetings, the same to be read to the assembled brethren at such meeting, and I believe that the result would make all feel the tie of lodge membership to be stronger and better.

Let us not forget, that during the coming year we must largely increase our numbers in old Oregon, never forgetting, however, the character of our membership, which should ever be above reproach, and only such persons as possess that true fraternal spirit, which is essential to the success and advancement of our splendid organization.

In conclusion, brethren, let us never forget that the success of our home lodge depends upon ALL of its members; YOUR presence is needed at all its meetings; it is your business to know what is being done in your lodge, and to assist in seeing that it is being done right.

Brothers, I bid you "God speed" in your good work and extend to you the sincere wish, that happy and prosperous may be this coming New to you all.

Sincerely and fraternally,

Attest:

E. E. Sharon,

Grand Secretary.

Thos. F. Ryan,

Grand Master.

The current owners of the hall (a mother named Sharon and her son Ryan) renamed it the Village Ballroom. It was built in 1909. Previous owners called it the Woodlawn Hall, the Rose City Ballroom, and the Scarlett Ballroom. When in the process of buying it, the mother was extremely nervous about making such a large purchase. She attended a garage sale in Woodlawn and bought a packet of letters relating to the Odd Fellows. She found this letter in that packet (see packet image on page 17). After reading to the end of the letter, she noted the signatures were of two dignitaries named Sharon and Ryan. She then felt joy and vast relief and knew that they were meant to own this historic building. (Courtesy Sharon Flegal.)

This illustration shows locals going up the side stairs to the ballroom. The two storefront entrances led to a billiards room; the "private reserve of the male lodge members, each of who considered himself to be somewhat expert at the game . . . the game was thought by the women to be slightly sinful, vaguely mysterious, and completely unnecessary." (Courtesy Ted Hoff, page 27.)

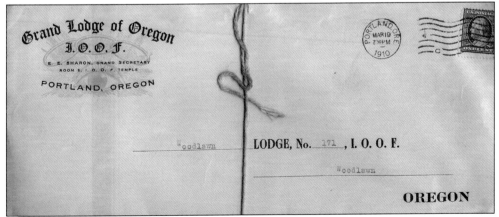

The fateful packet of letters pictured is almost 100 years old. Ted Hoff writes, "Woodlawn . . . was once an independent little town but lost its place on the map when Portland . . . grew around it. While it no longer existed officially, many older residents still bridled when they received mail addressed 'Portland, Ore.' They continued to write their return addresses as Woodlawn, Ore."—a fact which accounted for a lot of lost mail." (Courtesy Sharon Flegal.)

This letter shows the importance of the railway to members who used it for transportation to meetings. This one went from Woodlawn into Portland. They had to make arrangements for discount delegate travel over a month in advance. The Town of Woodlawn granted the charter for the Odd Fellows Lodge. (Courtesy Sharon Flegal.)

This is the Woodlawn trolley number WL 409 on its route. Notice most of the trees behind the trolley are the same age and size. They are probably second-growth Douglas Firs about 25–30 years old, the preexisting trees having been harvested. (Courtesy Richard Thompson.)

The Odd Fellows successfully negotiated for the discount agreements and could ride into town for the Grand Encampment and Rebekah's Assembly. Fares at that time were considerably less than $1. (Courtesy Sharon Flegal.)

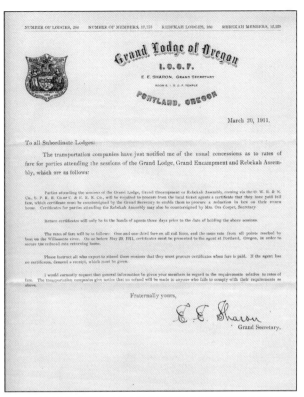

Ted Hoff wrote, "Bingo was a Saturday night event and the ballroom was jammed with people from miles around, most of whom were not Odd Fellows, just hoping to get lucky. In those days getting lucky meant winning a set of glasses or a box of Hershey bars." In 1981, when this picture was taken, the Odd Fellows ran fund-raising bingo games for smokers in one side of downstairs and for non-smokers in the other side. (Courtesy Historic Resource Inventory [HRI].)

The hall was given this spiffy paint job by the newest owners, who continued the tradition of supporting the neighborhood association by allowing them to meet, at no charge, in the right-hand ground floor storefront area. Now the right front storefront is run as the Second Time Around boutique thrift store and the left storefront is Brickwall Music Store.

A Sunday dancer goes up the steps to the sacred dance. Compare this image with Ted Hoff's description of Woodlawn women in the 1940s. "There were at least fifty or sixty women. . . . They started, ten abreast, at one end of the ballroom in their shimmering gowns and began marching . . . Week after week they gritted their teeth, looked tough and determined behind their corsages and met to practice marching again."

700 NE Dekum
Portland, OR 97211
503.283.1100
info@villageballroom.c

the
Village
Ballroom

This postcard shows the ballroom interior in 2007. It is a popular place, sometimes rented out for weddings, other times for parties. As always with ballrooms, keeping the sound levels appropriate is a concern. Ted Hoff wrote, "On dance nights, with all those steamy bodies filling the main ballroom they opened the windows and the thudding, stomping, clanking, and tooting filled the neighborhood."

The interior of the ballroom is decorated for the Sunday Sacred Circle dance. Men and women greet each other with hugs, and the feeling is quite lighthearted as the DJ plays a trance-able, danceable music. A variety of events, shows, and classes are offered at the Village Ballroom, from weddings to small conferences. Parking is convenient as is access via public transportation.

This boy is reading, not watching the dancers. Ted Hoff wrote that in the 1940s he "was mesmerized by this militant display of whispering satin, giant corsages and bristling fans that clicked and whickered as the women clomped by. I had never seen anything like it and the sight of massive bosoms heaving by me to the strains of John Philip Sousa initiated sexual fantasies which, for many years, caused confusion whenever I heard band music."

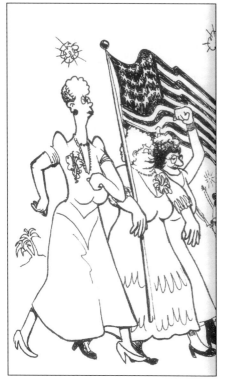

"The ladies' marching plan was to get to the other end, split into two rows, one row turning left, the other right, then circle back to join again and repeat the process. Unfortunately, some of the women were not all that great at navigation and began veering badly to the left or right shortly after leaving the starting line. By the time they were halfway down the room, the rows had begun to disintegrate." (Image and quote courtesy of Ted Hoff.)

Three

STATION 29

This image of the firehouse, Station 29, is from a glass-positive image (instead of being developed onto paper, the image was transferred onto glass). Note the fancy ornamental brickwork and the unpaved streets. The station was built on the triangular block in the center of the first street map illustrated, just below where the railroad track starts its curve. The partial street just below the firehouse block is now called Liberty Street, and a full city rectangular block fronts on to Durham Avenue. That block fronting Dekum Street was the location of the extremely popular Woodlawn Odd Fellows Hall. The building was home to the firefighters on the upper level and a stable for the horses on the lower level. The door was wide enough for the team of two horses to pull out the pumper wagon. The city expended a significant amount of dollars burying cisterns in the streets. When there was a fire, the horse-drawn engine and firefighters would rush to the nearest cistern and pump the water up and out of it. (Courtesy SPARC.)

This is the Station 29 crew on the apron. This 1913 crew is standing in the fire doorway in front of their horse team. Much effort was made to match the horses for coloring and size. These horses were very valuable, being of steady emotions and trained to actually run toward flames not away. (Courtesy SPARC.)

This is a fire engine now housed in the Portland Fire and Rescue Safety Learning Center and Fire Museum. If the firehouse had no horses, the firefighters would pull the engine through the dirt or mud streets. They also had to hand wash their hoses and hang them up to dry in the firehouse after each use.

The dedication of Station 29 brought out the firefighters and their families. Note the rain-wet street. The photographer is standing on Durham Street, looking southwest. The building is on a triangular block bordered by Dekum and Madrona Streets and Durham Avenue. This block used to be the site of the train station. (Courtesy SPARC.)

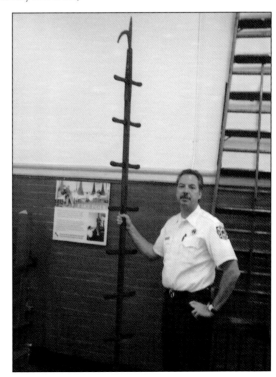

Don Porth, the fireman who guides tours through the fire museum, shows the type of wood ladder that was used to reach upper stories. The hook would dig into the windowsill, and the firefighter would clamber up the ladder. He says it is quite sturdy, but the author has doubts. (Courtesy SPARC.)

In 1920, the firemen decorated their truck with flowers so it could participate in Portland's Rose Festival, a major annual event that continues today. In the 1920s, bedecking the truck, car, wagon, or other parade entrant was not done to camouflage the vehicle but to beautify it. It often rains on the Rose Festival Parade that takes place in May. (Courtesy SPARC.)

This 1935 photograph shows the elaborate rock garden that was built by the firemen around the firehouse. Notice the large toy boat moored to the lighthouse island. There were pathways, drinking fountains (not visible in the photograph), and goldfish in the ponds. Longtime residents tell of flooding the streets around the firehouse in winter and then going ice-skating. (Courtesy SPARC.)

The bridge was large and sturdy enough for three or four people to stand at one time on it. To the left of the lighthouse is a water wheel. George Hollet (now deceased) noted in his memoir that "in the winter, when the streets were bad, we put our automobiles on blocks and we had dances in the street in front of the fire station." (Courtesy SPARC.)

Notice the plants landscaping this inventive focal point. The child standing among the garden stones is one of many who would eventually play at the station, when it was turned to a Boys Club run by the Salvation Army in the 1950s. Ernestine Brame said that she used to send her boys over to play at the club after school, and they never got into trouble. (Courtesy SPARC.)

The building style is called 20th-century Italian Renaissance. This photograph is from a 1938 yearbook showing members of Station 29 and their rock garden, of which they were justly proud. Compare this firehouse photograph with the following image. (Courtesy SPARC.)

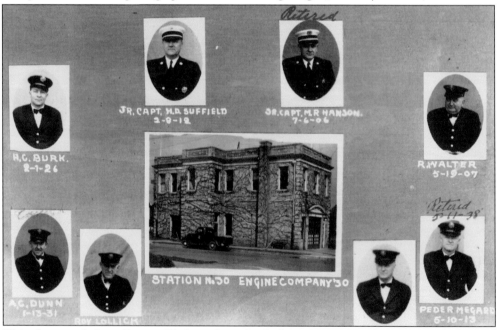

This photograph from Station 30 shows how the firehouses in use at that time used identical constructions. Special features of that style are the flat roof, a simple cornice, and stuccoed walls with brick quoining at corners and windows. When fire engines became larger and could not go out the doors without major remodels, many firehouses were sold and converted to other uses. (Courtesy SPARC.)

The Woodlawn firehouse was active in the 1980s in a new role, housing the J. R. French Company, painters and decorators. Their sign advertised "industrial, commercial, residential wall coverings." Recent discoveries revealed that this was actually a cover for a fencing operation working out of the basement. Stolen goods were dropped down the coal chute in the street. This view of the firehouse is from Dekum Street, and also visible to the right of the firehouse is one of the other historic structures, a former grocery building being used as apartments at this time. (Courtesy HRI 595-3)

In the 1990s, the firehouse was the residence of a single man who was very active in the Woodlawn Neighborhood Association. He painted it red and black, and planted raised beds and trees around the property. It has high ceilings on the second floor and lovely views. Downstairs had been reconfigured into a number of not-so-useful rooms, so he parked his car in the garage and mostly lived on the second floor.

In 2006, the owner married and moved away. He sold the firehouse to people who are in the process of converting the downstairs to an Italian restaurant and the upstairs to a combination residence and naturopathic clinic. They pulled out all the trees and beds along Dekum and Madrona Streets. To the left, in front of the door, construction debris is visible. Ted Hoff remembers the excitement of a fire call in the early 1950s when he was an energetic boy. The fire trucks would leave the station, and the door would be left open. He and other boys would race into the station and go to the second floor, where they would slide down the fire poles. On a good day, they would have about eight trips down the poles before the engines would return. Martha Burnett remembers that the Boys Club ran until a child was injured after being pushed and falling from the upper floor.

Four

LOCATIONS, LOCATIONS, LOCATIONS

The current boundaries of Woodlawn are south on Ainsworth Street; west on Martin Luther King Jr. Boulevard; east on Northeast Twenty-second Avenue; and north on Columbia Boulevard. This shot shows Ainsworth Street (called "the Avenue") in 1937. Ainsworth was named after John Commigers Ainsworth, a steamboat captain by the age of 22 and a steamboat, railroad, and business magnate in his 50s. When the Woodlawn Neighborhood Association (WNA) was doing its planning in 1993, we wanted Ainsworth, which is a lovely boulevard with trees in a grassy median, to be an entry gateway to the neighborhood. The original plan was to have a sign reading "Welcome to Woodlawn Neighborhood," but it was a "Welcome Woodlawn Neighborhood" sign that was actually installed on a pillar of the Walgreen's store that replaced this garage. Look west at the Texaco station across the street (then called Union Avenue after the Union Army, and now called Martin Luther King Jr. Boulevard). That Texaco station is long gone and is now a drive-through Starbucks.

This 1937 shot is turned 180 degrees from the previous one and looks east down Ainsworth Street. The signs on the building show there was a store called "Market Grocery." There is Helen's Beauty salon room to the right of the grocery. (Courtesy SPARC.)

Lombard Street is the major road just east of Columbia Boulevard. It was named after a man active in real estate in the early 1900s. The rail lines of today go in between Columbia and Lombard. This 1937 photograph shows a building offering "Entertainment!" However, it is in the heart of the Depression, so no entertainment is to be had at this place. This photograph is looking east. (Courtesy SPARC.)

Taking another look at the same business, it offered entertainment and sandwiches, but the small signs in the window say it is for rent. The street directional signs point to the cities, Hood River (famous for wind and kite surfing and glorious fruit trees), and the city of Bonneville. Astoria is a coastal city about 100 miles from Portland, and St. Johns is only 15 minutes from Woodlawn. (Courtesy SPARC.)

This picture was taken standing on Ainsworth Street and looking north up Union Avenue. The small sign on the building to the right reads "Meats." Notice how the road is now sloping down toward the Columbia River, which divides Oregon from Washington. The same car appears in both images on this page and may have been the photographer's. (Courtesy SPARC.)

This shot is looking north toward the state of Washington from the intersection of former Union Avenue, now Martin Luther King Jr. Boulevard, and Columbia Boulevard. In 1937, the trolley tracks and wires overhead were still visible. Across the street, the sign announces the Interstate Auto Camp, and it looks like they are offering cottages for rent at $1 and up. The Shell gas station to the right offers green stamps with the gasoline purchase. (Courtesy SPARC.)

This picture is looking south from Columbia Boulevard. Newberg Meat Company is also a grocery store. This shot shows Union Avenue as a thoroughfare. Improvements in the 1990s to befit the name of boulevard have included center islands planted with trees, elegant streetlights on the sidewalks and, most recently, refuges and parking spaces. A close look reveals a shop offering curb service to purchase some "Bar-B-Q." (Courtesy SPARC.)

This shot of Ainsworth Street looking south down Union Avenue shows the Gilmore gas station. Note the Gilmore sign in the shape of a running man with a checkered flag. They offer Gilmore Red Lion Tetraethyl with the subtitle "Monarch of ALL." (Courtesy SPARC.)

This house on Ainsworth Street was moved here in the early 2000s as a timeworn, unpainted, no chimney, barely roofed shell of a building. The owner has spent years making it a showpiece of its kind. This is the rare kind of infill happening in Woodlawn. The houses that are being built have often not fit into the neighborhoods as well as this one has.

Many houses in Woodlawn are of historic interest. This 1905 house on Ainsworth Street is in the style called American basic. It is notable for a bell-cast hip roof with a shed dormer and for its end wall chimney that does not show so well in this image. This property was photographed in 1981 as part of the Historic Resource Inventory (HRI) conducted by the City of Portland. (Courtesy HRI 594-29.)

This picture shows what the house looks like today. The chimney has been painted so that it stands out as a feature, and you can also see the bay window on the chimney side.

This drab building is used for storage. In its heyday, it was Woodlawn's nickelodeon. The two holes in the bricks on either side of the building front are where the round white globed gas lights (as seen on the cover) used to be. To its left is the sign for the Tam O'Shanty Tavern that took over after the Tam O'Shanty Confectioners closed down. (Courtesy Historic Resource Inventory HRI 798-24.)

This photograph shows the building at 814 Northeast Dekum Street looking much the same. The sign for Tam O'Shanty Tavern is long gone, and where it used to be is a triangular, high-walled courtyard. Rumor has it that the future wife of one of Oregon's governors once worked in the tavern. In its heyday, the Tam O'Shanty was a meeting place to have a beer after work and then go home.

This building was originally a grocery store. Small signs in the windows offer S&H (Sperry and Hutchinson) trading stamps. The former grocery store next door is now the Rose City Appliance Store. In recent years, the apartments above have housed couples and for a time it was a place for troubled men to live quietly and reintegrate into society. (Courtesy HRI 728-24.)

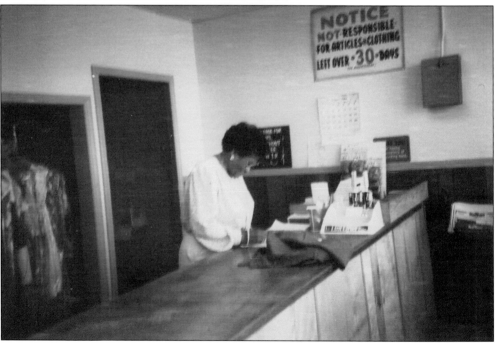

For many years the ground floor was a dry cleaner's business run by Willie Ranson, shown here at the front desk. Willie has been a longtime active board member of the Woodlawn Neighborhood Association. (Courtesy of Willie Ranson.)

This image shows how the building looks today with a natty coat of pale gray paint and purple bordering the windows. Visible to the right are the new sliding garage door and windows that were installed below the multiple pane original windows. As of Halloween 2007, this building is now the Good Neighbor Pizza parlor.

The Rose City Appliance Store was active in the 1980s. Before that, it was a grocery and Mr. Neville's butcher shop during the 1940s. Ted Hoff noted that "I never much liked Mr. Neville after I found out he was the one who butchered my pet rabbit when we were low on food. I think he knew it too, because he never looked me in the eye."

This store was the Dekum Market through the 1990s, and the Woodlawn Neighborhood Association worked with the owner, neighbors, the Oregon Liquor Control Commission (OLCC), and the police to try to stop drug dealing around the store. Yet, nothing seemed to work. In 2003, "coincidentally" at the same time that the movie *The Hunted* was being filmed on Dekum Street, the drug dealing was stopped, and the store closed too.

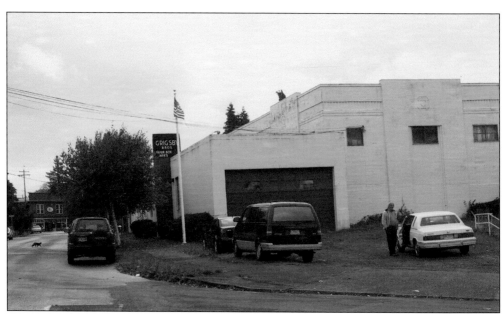

This is the Grigsby Brothers Paper Box company, one of the oldest buildings and the former well-house for the town. The people pictured are Terry and Janet Grigsby (in the car). There was a fight between Portland and Woodlawn, and Woodlawn was forced to accept being on the Bull Run water supply, so the well house was converted to an icehouse in the early 1930s. The Army Corp of Engineers set up their Vanport Flood headquarters here.

The Woodlawn Methodist-Episcopalian Church, as seen in 1982 on Tenth Street, is still in use today. It is architecturally notable for its bell tower with a pyramidal, bell-cast roof. The round windows with quatrefoil tracery are on both sides of the church. (Courtesy Historic Resource Inventory HRI 594-31.)

This is a contemporary photograph of the Woodlawn Methodist-Episcopalian Church. The image was taken down the street to the left of the main entry (seen in the lower left of the previous photograph) because shrubbery obstructed the view if one stood directly across the street from the church. In 1956, they built the bigger church on the corner of Northeast Fifteenth Avenue and Dekum Street.

This building on Durham Avenue was originally a grocery store. Durham Avenue was named after Richard L. Durham, one of the three founders of the OLIC. His father emigrated from New York to Oregon and named today's city of Lake Oswego after Oswego, New York. The 1981 image shows it in use as an apartment building. (Courtesy HRI, 595-5.)

Rumor says that this building was once a brothel in the 1990s. The vacant lot to the right (barely visible in the photograph) is what remains of the building shown in the previous photograph. A developer bought the site and worked to renovate the building, however the building collapsed in a windstorm during the winter of 2006.

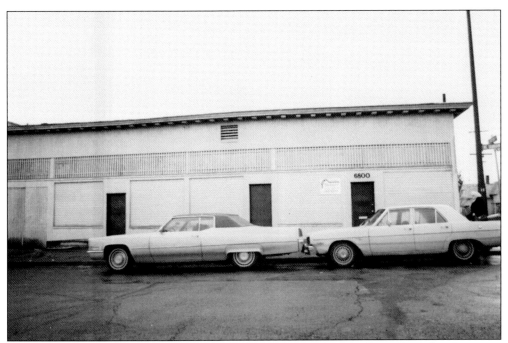

This is the former building at 6800–6808 Northeast Durham Avenue that collapsed in the winter of 2006. It was originally the Chas. E. Chatfield Drugstore built in 1920. This 1981 photograph shows it converted to storefronts. Its architectural significance is in its flat roof with projecting cornice. (Courtesy HRI 595-6.)

This is what is now planned by the developer Sakura Urban Concepts, LLC, for the site. Commercial spaces would be on the ground level and condominiums and/ or apartments on the second and third floors. The developer met with the Woodlawn Neighborhood Association to address the residents' concerns and design a building that fits into the neighborhood. (Courtesy of Woodlawn resident Eli Haworth.)

This symmetrical house on Dekum Street is a Queen Anne vernacular–style residence, built in 1890. It has a cross gable roof, and a projecting gable over the polygonal bay window. The shingles are imbricated and there is a decorative bargeboard. The cornices are boxed with returns. The recessed balcony with a horseshoe arch looks out toward the Columbia River and Mount St. Helens. (Courtesy HRI 798-21.)

The current owners have lavished much time and attention on restoring the house to its period splendor. Their landscaping embellishes and does not overwhelm the house.

This house on Ninth Avenue, as seen here in a photograph taken in 1981, was built during the 1890s in the Queen Anne vernacular style. Typical of that style is the multi-planed roof with mansard and medium gable, the boxed cornice with return, curvilinear brackets, fish-scale shingles, projecting gable over the polygonal bay window (at the left), and most distinctive, the diamond-shaped window. It also has a drop siding. (Courtesy HRI 595-17.)

The current owners of the Ninth Avenue house have beautifully maintained the exterior and softened the rather plain porch and bare grass with clinging vines and lush plantings.

This lovely Queen Anne vernacular house on Tenth Avenue in 1982 looks very different from houses either side of it. This is common in Woodlawn where large original lots were subdivided over the years, and houses were built in the styles of the day. Historic design guidelines were developed in the early 1990s. Many of the houses in Woodlawn were built after World War II. (Courtesy HRI 906-10.)

This is a picture of the house as it appears today. It is notable for its multi-planed gable roof and beautiful fish scale shingles. The gable dormer with a recessed porch is the most distinctive feature. There is also a gable over the polygonal bay window at the front right. (The angle of the front bay window is best seen in the previous photograph.) The entry porch has turned columns. There is stained glass in some of the windows.

This 1982 image shows the elaborate decorative woodwork under the front gable of this Queen Anne vernacular house on Sixth Avenue. Note the typical Queen Anne polygonal bay window. It is harder to see the curvilinear brackets, but look to the back left at what seems to be a side door and you can just make them out. The recessed entryway is also a Queen Anne feature. (Courtesy HRI 798-29.)

This contemporary photograph shows the house with modern siding covering up the period wood working detail, but the general Queen Anne shape remains. It is estimated that the building was constructed in the 1890s.

This is one of the homes formerly owned by Woodlawn pioneer Lewis Love. This is a much more refined house he had built when he was very wealthy in 1908. The style is called American basic. Decorative brackets at the eaves are clearly visible. The encircling porch has Tuscan columns. There was an elliptical light in the entrance. The original house had a balustrade on the porch and porch roof. (Courtesy HRI 595-19.)

This is the same house today on Northeast Sixth Street. The balustrades have been rebuilt both on the porch and the porch roof. It looks like it has been converted to a fourplex. The first house Love built down in the lowlands was handmade. That house was large, boxy, and gabled. Some said, however, that once it was painted, it was the best looking house in the country.

These are graduates of Woodlawn School at a 50th reunion. Martha Burnett (born Martha Van Beck and a descendant of Lewis Love) provided the photograph. She grew up on Oneonta Street which branches off Durham Avenue. Lots of her Van Beck family had and still have houses on Oneonta. Oneonta means Place of Peace and was so named in 1889. The first Woodlawn School was built on Union Avenue. (Courtesy of Martha Burnett.)

This image shows a reunion of the Townsend clubs, the neighborhood assocaition, which met at Woodlawn School in the 1960s and 1970s. Martha Burnett remembered that Woodlawn had lots of cherry trees, mostly Royal Anne, but some Black Lambert, as well as apple and quince trees. (Courtesy of Martha Burnett.)

Woodlawn School was built in 1926. Ted Hoff remembered that the cherry trees in front were rescued and planted by one of his teachers. The building is designed in 20th century Georgian style, with a flat roof and crenellated parapet, brick work with belt courses and entrances, smooth stone at the windows, and quoining at the edges. There is an open book decorative motif over the entrance. (Courtesy HRI 595-16.)

This is the Woodlawn School today. The playground is an excellent place to watch fireworks across the Columbia River at Fort Vancouver's annual Fourth of July show. Notice the street is sloping downhill to the left. The left end of the school is bordered by Holland Street, which is the last street before the bluff steeply drops off down to Lombard Street and Columbia Boulevard.

Holland Street is one block north of Buffalo Street. This photograph shows 1962 Northeast Buffalo looking east from Seventeenth Avenue. (Courtesy SPARC A2000-033.)

This is a 1971 shot of the Grigsby Brothers Paper Box company. Notice that the street was unpaved, even at this recent date. After being the icehouse, it was converted to the Rose City Brewery in the 1930s and made beers of fine repute. When the brewery closed, the building was vacant, and stored sandbags used in the recovery from the tremendous Vanport flood. (Courtesy SPARC A2005-005.)

This 1971 picture is of a house on a five-way intersection at Portland Boulevard. Such intersections and the angled streets make it easy to get lost here. Please note the little child standing at the right side of the street. Portland Boulevard was recently renamed Rosa Parks Way. (Courtesy SPARC A2005-005.)

This 1971 view of the corner of Northeast Thirteenth and Bellevue Avenues is one of those places where infill opportunity was found. At the back of the photographer is a triangular parcel of land that the Woodlawn Neighborhood Association hoped could become a pocket park in the 1990s. Instead, a Habitat for Humanity house was built on this small parcel, and the house is now its own island. (Courtesy SPARC A2005-005.)

This 1971 shot of Northeast Thirteenth Avenue and Highland Street is interesting because the photographer's assistant can be seen at the right, standing in sunglasses, suit, and tie holding a chalk board sign behind a man who is kneeling and apparently working on his garden fence. The simple farm houses along this street are typical of older houses dating back to the 1920s and 1930s. (Courtesy SPARC E A2005-005.)

This is Northeast Bellevue and Northeast Portland Boulevard as seen in 1971. This shows the triangular parcel of land at 11 o'clock where the Habitat house was built. This image looks north down Thirteenth Avenue toward Dekum Street. Northeast Dekum Street and Thirteenth Avenue was the site of one of the problem grocery stores in the 1990s. In the far distance is the state of Washington. (Courtesy SPARC 5 A2005-005.)

The photographer's assistant can be seen in front of the Volkswagen van to the right, holding a sign identifying this as Northeast Stafford and Eleventh Streets. Stafford is halfway down that bluff. This street too was unpaved. This might have been exciting to drive when it was muddy. (Courtesy SPARC 6 A2005-005.)

Here is a house on Buffalo Street today. Buffalo Street was named after Buffalo University. Many neighbors get into the holiday spirit and decorate their houses. Older styles like this one do well with haunted house themes.

Five

BUILDING THE PARK

The owner of this house has a manicured yard and this topiary nest is in a bush that has been trimmed in the shape of a 10-foot-tall Easter basket. The house is a ranch style one level in an area of houses of that type.

This view of Woodlawn in the 1970s shows in shading which houses were in good condition and which were not. The houses most darkly colored were considered for condemnation. Notice the majority of them are to the center left of the map in the oldest part of Woodlawn. In 1970, the department of Housing and Urban Development agreed to provide the funds for a park.

This is a landscape architect's model for Woodlawn Park. The street to the left angling up is Dekum Street. The street bisecting the park is Claremont Street. Originally Claremont was to be closed but instead it was made into a bridge. The streets closed off (Woodlawn Street for example), were dug up and chunks were used to build park walls. (Courtesy Jan Clutter.)

This is another view of the park design, this one focusing on the swimming pool built in its own wooded area. That pool has been gone for years but look Woodlawn up on www.MapQuest.com and the indication "Woodlawn Park And Swim Pool" pops up. (Courtesy Jan Clutter.)

This is the pool as it was being constructed. When it was finished, the pool always seemed like a dark, damp, and dank place, and even when it was filled and maintained. It was not very inviting. It was not very big, either; it was smaller than a tennis court. The pool was not missed when it was taken out in the park's redesign. (Courtesy Jan Clutter.)

Some of the streets of Woodlawn were piled up and ready to be used as walls. "Some people actually died because they were heart-broken," Burnett said. "There were a lot of old-timers on Woodlawn Street. When you have been someplace all that time, it really upsets people," as quoted in "A History of Woodlawn Park" by Andrew Longteig and published in the *Woodlawn Voice Newsletter*. (Courtesy Jan Clutter.)

This image shows workmen building walls in the park. The author tried to find where this particular wall was but the trees and houses have all changed, and according to Andrew Longteig, "there were quite a few trees removed as well. Fortunately there were 700 to 800 new trees planned . . . [and] Woodlawn Elementary School students helped plant some trees." (Courtesy Jan Clutter.)

This picture, taken looking northward at Woodlawn School, shows the Claremont Street Bridge supports being built. In 1970, the area for the park contained 37 parcels, about half of which had not been developed. Some of the houses targeted were along the former Woodlawn Street that ran between and parallel to Oneonta and Winona Streets. A vote was taken at the Woodlawn Neighborhood Association in April 1970, and residents agreed to form the park. (Courtesy Jan Clutter.)

Woodlawn residents toured other city parks for ideas and developed a questionnaire to get feedback from neighbors. "This site was mostly an area of deteriorated housing," said the park's codesigner. "I could think of only one or two houses that were like that," said Martha Burnett. "Most of them kept up their houses nicely; you could tell it was an older neighborhood. A lot of people wanted to keep their homes. They were shocked," wrote Andrew Longteig. (Courtesy Jan Clutter.)

The wedge-shaped concrete to the left became part of the storage rooms under the bridge. Andrew Longteig quoted Willie Ranson: "My brother lived on Oneonta and he had a nice house. The people across from them had a fairly new house, maybe built in the 1960s. They kept it up pretty nice over there." (Courtesy of Jan Clutter.)

This images illustrates how the bridge looks today. The Girl Scouts used to meet in the park and make crafts and have a free lunch. Nowadays, in the summer, the parks department open the doors and bring out ping-pong tables and lunch tables. During the summertime, free lunches are served and there are supervised activities.

"The park has many defining features. There's the amphitheater on the northwest side, where the Oregon Symphony performed in August 2005," wrote Andrew Longteig. This photograph shows the amphitheater under construction. Today it is bounded by trees at its back and sides, and is a lovely place to sit and watch people walking their dogs or practicing their golf shots in the open area it faces. (Courtesy of Jan Clutter.)

This picture shows the construction of one of the several basketball courts at the Dekum Street end of the park. There are two courts for teenagers and one court for little kids. "In 2002, Woodlawn became one of 35 area parks to receive new basketball hoops and a synthetic surface [on the main courts] made out of recycled shoes, courtesy of Nike," as quoted in the Longteig article. (Courtesy of Jan Clutter.)

The park has newly rebuilt picnic tables that are often used in spring, summer, and fall by families and by childcare providers who sit at them and watch their kids frolic in the play area. Some of the tables are inset with checkerboards. The Woodlawn Neighborhood Association sponsors Neighbors' Night Out in August each year and around a hundred neighbors meet and celebrate with a shared picnic and potluck foods.

This photograph shows the children's water feature. Out of sight to the left, about six feet from the blue "coil," is a blue post with a child-sized hand indentation. When a child puts their hand in the handprint, the blue and green water features spray with cool gentleness and variety. Park benches and tables nearby allow parents to chat while watching their kids get sopping wet.

Six

ACTIVISTS IN ACTION

This image shows something both ordinary and extraordinary. This trash can is actually 10 feet high, with 7 feet of it sunk in the ground. It is fitted with a very long trash bag that only has to be emptied once a week. The person in this photograph is Lee Martin, a former land use chair of the Woodlawn Neighborhood Association.

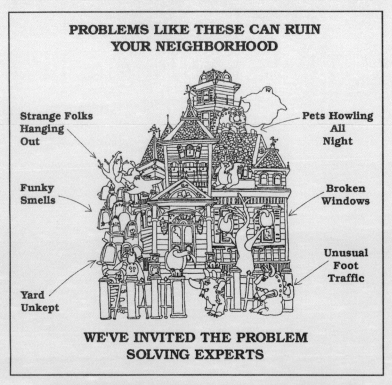

Woodlawn Neighborhood Association

Crime Prevention Fair

PROBLEMS LIKE THESE CAN RUIN YOUR NEIGHBORHOOD

Strange Folks Hanging Out

Pets Howling All Night

Funky Smells

Broken Windows

Unusual Foot Traffic

Yard Unkept

WE'VE INVITED THE PROBLEM SOLVING EXPERTS

• CITIZEN'S SAFETY, HOME SECURITY, CRIME PREVENTION
• LANDLORDS AND RENTALS, DRUGHOUSES, AND MORE!

Woodlawn School
7200 NE 11th

**11 - 3 p.m.
Sat., May 18th**
FREE REFRESHMENTS
Call **(503) 823-4763** for additional information

The Woodlawn PTA was the first organized group of activists in the neighborhood. A group of the PTA members wrote the first Woodlawn history. Then the Woodlawn Improvement Association became active in the 1970s when the Federal Model Cities dollars became available. The name changed when the Woodlawn Neighborhood Association incorporated as a 501(c)3 organization for public benefit back in the 1980s. Woodlawn neighbors and activists are going strong today. This is one of the flyers the Woodlawn Neighborhood Association put out in the early 1990s as it wanted neighbors to know there was an association that aimed to resolve problems. More and more the associations needed to learn how to work with the important city bureaus of transportation, housing, building codes, district attorneys, and police. Around this time, a police captain named Tom Potter was active in the northeast area with a theory of community policing.

The Woodlawn Elementary School has been a major partner at times with the Woodlawn Neighborhood Association. This is one side of a school plan showing their goals. In the early 1990s, the Woodlawn Neighborhood Association and the school jointly requested a grant for the WISE program (Woodlawn Initiative for Success and Empowerment).

This is side two of the school plan. Woodlawn School has often recruited members of the Woodlawn Neighborhood Association to serve as volunteer reading tutors for the SMART program (Start Making A Reader Today). This wonderful program has an adult read to two selected children once a week. The same adult and same children participate week after week. This builds the children's interest in books and their abilities to read.

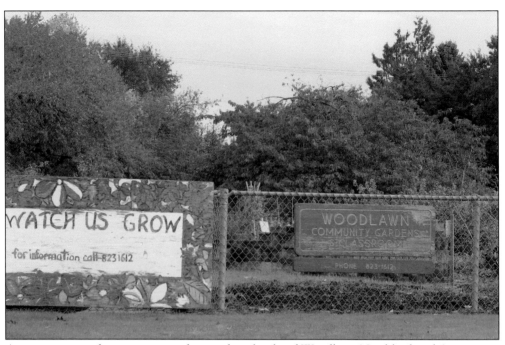

A committee involving certain teachers at the school and Woodlawn Neighborhood Association members began plans in 1996 to create a community garden. A City of Portland Parks Bureau employee, Leslie Pohl-Kasbau, worked with the association for years. Finally it was decided that a parcel of land between the school and the park could serve as the Woodlawn community garden. Martha Burnett remembered that an Asian family used to live where the community garden is now.

REAPING WHAT THEY SOW

An ambitious new garden project takes Woodlawn students back to the land

The joy of learning grows in a child's soul just as a seed sprouts and reaches for the sun in a garden.

Soon, the two will entwine at Woodlawn School in Northeast Portland as The Garden Classroom gets under way this spring. More than 500 students, pre-kindergarten to sixth grade, will have access to a place that brings learning down to earth.

Patterned after a schoolyard garden program instigated by Berkeley chef Alice Waters at her daughter's school in California, The Garden Classroom will be used by Woodlawn's teachers to enhance the learning process and cultivate self-esteem in a student body in which 85 percent of the children live below poverty level.

Waters, owner of Chez Panisse and the chef credited with transforming American cuisine with menus built around fresh, regional foods, says she couldn't sit still and watch future generations come unhitched from the earth and the cycles that sustain life.

"I'm thinking about the world my daughter's going to live in," she says from her home base in Berkeley. "I'm trying to find a way children in the future can eat wholesome, pure food."

The community struggled with the issue of where to get the funding to build the garden. A group of well-connected Portland philanthropists knew celebrity chef Alice Waters. She was famous for having school kids grow and prepare fresh fruits and vegetables and so learning the connection between the farm and the table. This group of philanthropists breezed in, did a fund-raiser with Alice Waters, and this boost of money got the garden up and running in 1998.

This image shows an announcement for the grand opening of the garden. The last organization listed is the Woodlawn Episcopal Church. The church that started on Tenth Avenue built the larger church on the corner of Fifteenth Avenue and Dekum Street. This church has had community outreach programs for years. The church has changed names over time and now the community outreach center is known as the Woodlawn Community Resource Center (WCRC.)

Woodlawn
Community Garden
coming soon!

Ground Breaking:
Watch for the official
ground breaking in November. The
Community Garden will be located
between Woodlawn School and
beautiful Woodlawn Park.

A Place to meet and a place to grow.
The garden is being designed with the entire
Woodlawn Community in mind. Plant vegetables,
herbs and flowers in one of the many individual
plots or share a space with a friend.

For more information contact:
Portland Parks and Recreation (Leslie Pohl-Kosfau at 823-1612)
Woodlawn Neighborhood Association or Woodlawn School

This is a joint project: Portland Parks-Community Gardens,
Woodlawn Neighborhood Association & Portland Public
Schools and Woodlawn E.C.E.C.

The city planted both a male and female hardy kiwi vine on the chain-link fence surrounding the garden. Very few people, until now, knew what those vines were and how delicious the ripe fruit are.

Some gardeners work their plots year round. Some of the summer vegetables grown in the garden include chard, fennel, garlic, onions, and lettuce. At the harvest festival, some of the food grown in the garden is donated to homeless shelters and charities. People use their plots for family (or family and neighbor) food and not for resale. Often a team of neighbors gets together to work one plot. The garden helps to strengthen the community.

This photograph also shows the Woodlawn Neighborhood Association reaching out and finding funding for a rare treasure. This is a Thai water jar that stands more than seven feet tall and can hold around 800 gallons of water. It collects rainwater from the roof of one of the school's portable classrooms and from the picnic table shelter to its right. The jar was dedicated during the garden's 2007 annual Harvest Festival.

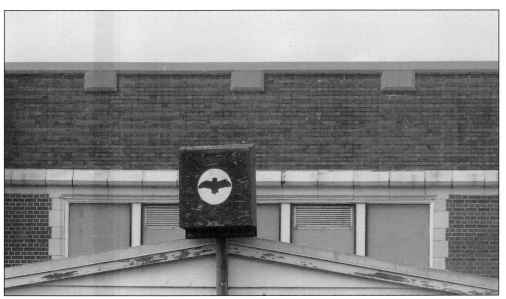

Part of having a garden is respecting the animals, birds, and other wildlife. This bat house has been perched above the roof of the portable school building immediately to the left of the Thai jar. Woodlawn Neighborhood Association activists sought and won grants in 2006 to stock a tool shed in the garden.

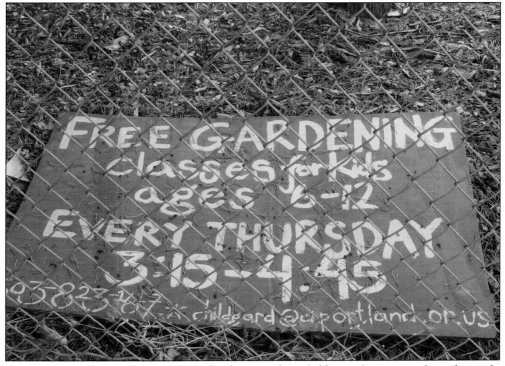

A sign inside the garden welcomes people who want their children to learn more about the earth. Another sign posted in the garden has a quotation from Mahatma Gandhi: "To forget how to dig the earth and to tend the soil is to forget ourselves."

Vera Katz

What are your views on consolidation of total metropolitan area?

How important to you is a strong land-use planning board in view of the fact that so much of our fertile agricultural land has already been sacrificed to urban sprawl?

This image shows an index card with a question for candidate Vera Katz (former multiple-term mayor of Portland). During the 1990s, the Woodlawn Neighborhood Association wanted to attract the attention of local politicians to our causes, and so the group held a number of candidate fairs. Questions such as the one shown in the index card often tested the candidates. The candidate fairs were held in the auditorium of the Woodlawn Elementary School.

Vera Katz was mayor from 1992 to 2004. In 1991, the Woodlawn Neighborhood Association received a $7,500 revitalization grant from the City of Portland that was used to sponsor a crime prevention fair, a neighborhood handbook, a children's art project at Woodlawn School, a neighborhood questionnaire, and much more. (Courtesy SPARC.)

To ALL of THE CANDIDATES—

HAVE ANY·OF YOU GONE
ON RIDE-ALONGS WITH
PORTLAND POLICE OFFICERS
+ WHAT WAS YOUR OWN
REACTION TO THE EXPERIENCE?

This image shows the questions directed to the candidates about going on "ride-alongs" with the police. The Woodlawn Neighborhood Association members got involved in community policing, a new term for knowing the police officers on your beat. The association thought that if the neighbors knew the police better, then residents would be more likely to confide in the police about crime. Capt. Tom Potter, who was later to become chief of police, and who is Portland's mayor in 2008, was a major proponent of community policing.

One component of community policing involved assigning officers to regularly attend neighborhood association meetings. This gave residents a safe place to talk to the officers without having officers come to their houses and run the risk of their neighbors labeling them a "snitch." This photograph of Mayor Tom Potter was obtained from Grace Uwagbae in the mayor's office. (Courtesy City of Portland.)

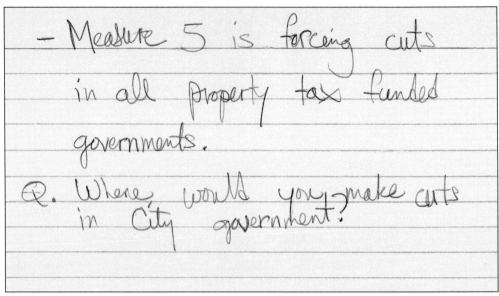

— Measure 5 is forceing cuts
in all property tax funded
governments.

Q. Where would you make cuts
in City government?

School funding has been a contentious issue in Oregon. Formerly property taxes funded schools and other community services that Measure Five made to be cut back. Community concerns were not addressed as quickly, and the numbers of new police hires began to decline since there was insufficient funding.

Blumenauer, Katz & anyone else!
In the past and the present the city govt has given away or
Foolishy spent Millions of $, 2-3 mill given to Preforming Arts ctr,
1-mill spent for Sullivan pump station Study, $300,000 spent to Remodel
+decorate "the PortLand Bldg" Entrance + etc window dressing scams
that did not benifit the public problems. We need hard earned
tax $ spent for, NEWer, Larger North + EAST Police Precincts, NEW
Modern 911 Campus on 122 st, + for Previntive Maintance of city
property + facilities – not window dressing projects, Not to be spent
How will you as Mayor Not allow our tax monies ~~more productive~~ ↓
in these + other non productive ways + areas ?
 Signed Mike Ready

The person named on the card as Blumenauer was Earl Blumenauer, then a city commissioner who became a federal congressman. The person who wrote the card was one of Martha Burnett's relatives who was for a longtime an effective Woodlawn Neighborhood Association activist. This image demonstrates that the activists were well informed and asked testing questions.

As a Christian I am greatly concerned about the fact that has been verbally reported to me that one of the problems the O.C.A. had with endorsing you is that you would daily consult the horoscope. How do you reconcile this with the Bible?

Anonomous Christian

The candidate fairs attracted a variety of characters as well as serious candidates. At one candidate fair, the character candidate came on stage accompanied by two friends garbed and ear phoned like secret service agents. Then there were perpetual candidates, those who ran in every election. And there were also single-issue candidates, such as Joe Doyle, who had a predominantly religious platform.

When Active, Established Block watches Are told by upper leval police officials that their observations of Drug & Prostitution Activities Are not valid And the only value of the block watch is to get to Know your neighbor How do you purpose to correct the farce of Community Policing?

By this time, the Woodlawn Neighborhood Association was becoming fed up with supplying the police information about crimes including, drug dealing, after-hours parties, drug houses, and most often having nothing done about these crimes. A murdered, naked woman was discovered in Martha Burnett's driveway. The murderer was caught and convicted, and it emerged that the murderer had attended one of those after-hours houses prior to the murder.

Currently it Appears thru the
NE/N. Experence that police
are only interested in moving
illegal Activity out of one
Neighborhood to Another. ~~The~~
~~police blames the first season.~~
How do you purpose to change
this to eliminate illegal Activity
Not Just move it?

In the late 1990s, the police prosecuted several major gang leaders under the Racketeer Influenced Corrupt Organization (RICO) laws, and they were convicted for eight or more years. The leaderless gangs immediately became less effective and were somewhat pushed out of Woodlawn into other neighborhoods. There are still gangsters in Woodlawn today, however, they are just not as rampant. No candidate had a good answer for how to eliminate crime.

Why weren't the people living
on N.E. Buffalo form 15th to 18th
notified of the zone change from
sengle family dwelling to multiple use
under the Albina Plan?

In 1993, the Woodlawn Neighborhood drafted its own plan as a subset of the greater Albina Plan. Many well-attended public meetings were held, as Woodlawn Neighborhood Association committee members and city planners decided on zoning changes and how they would like Woodlawn to look in the future. If the people on Buffalo Street were not notified of the zone change, either they tossed the announcements or they did not attend the facilitated community meetings at the school.

A major fund-raiser for the Woodlawn Neighborhood Association and other associations is the annual neighborhood cleanup. By charging a nominal $5 per carload and $10 per truckload, and by getting dumpsters subsidized by the city, the Woodlawn Neighborhood Association raised nearly $1,000. Those dollars are mostly spent on postage and flyers, and postcards notifying neighbors about other Woodlawn Neighborhood Association activities. Usually a great time is had by all.

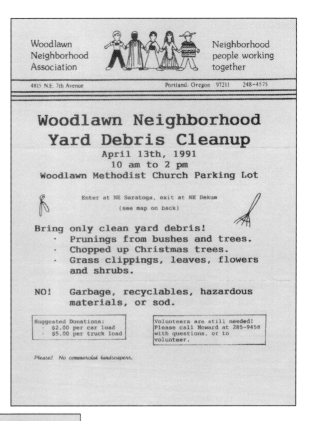

This flyer shows the parking lot that the Woodlawn Neighborhood Association used to hold the annual cleanup, as well as a farmer's market for one year. However, because it was poorly publicized, the farmer's market did not thrive. In later years, the volume of traffic choked neighboring streets and so the event moved to a new venue in 2007, the parking lot of Henry V meeting company on Martin Luther King Jr. Boulevard. Please see the photograph later in the book of the Henry V Company.

WOODLAWN ACTION NEWS

Summer 1993 Special Edition published by the Woodlawn Neighborhood Association

WOODLAWN COMMUNITY RESOURCE GUIDE

Inside you will find a special Woodlawn Community Resource Guide - which provides the names and phone numbers of programs which can help you and your family achieve security, self-sufficiency and support. Keep it handy for reference throughout the year.

The Community Resource Guide is published by the Woodlawn Neighborhood Association, as an activity under the Woodlawn Initiative for Success and Empowerment (WISE).

Funding for WISE and the printing of this Community Resources Guide have been provided by the Oregon Community Foundation (Neighborhood Partnership Fund) and City of Portland Bureau of Community Development (Community Initiatives Grant).

If you have ideas for programs or services to include in future Guides, or corrections to offer, mail them to Woodlawn Neighborhood Association, c/o Bill Weismann, 1720 N.E. Buffalo, Portland, Or. 97211

MULTI-CULTURAL FAIR SET FOR AUGUST 14

The Woodlawn Multi-cultural Fair will be held on **Saturday, August 14 from 12 noon - 8 p.m. in Woodlawn Park.**

The Fair will offer musical entertainment, children's activities and recreation, food vendors, and information booths featuring many community services. Woodlawn residents who can provide entertainment, be food vendors or sell crafts are still invited. Call the phone numbers below to get involved.

A Woodlawn Art Show will take place all weekend at the Woodlawn Methodist Church, NE 15th and Dekum. It will begin Friday evening and run all day Saturday and Sunday afternoon.

Volunteers are needed to assist with Fair set-up, clean-up, children's activities, security and the Art Show. We need you! Please **call Thelma Diggs at 285-5455 or Rev. Luther Sturtevant at 289-0284.**

This is the newer Woodlawn United Methodist Church. The church has been a good partner with the Woodlawn Neighborhood Association over the years and has often allowed some of its spaces for association meetings. After remodeling and upgrading the premises, the Woodlawn United Methodist Church is now offering the Woodlawn Community Resource Center (WCRC) room for Woodlawn Neighborhood Association meetings.

This image of a page from the Woodlawn newsletter shows cooperation with the school on the WISE project and the church to put on the multicultural fair. One goal of the Woodlawn Plan was to increase employment opportunities for residents, so the resource guide was created to tell of the skills and employability of our neighbors. In 2007, a grant was requested to do a new version of that guide.

This page shows that many of the local businesses supported the newspaper. In Hilda Erickson's childhood years of the 1910s to the 1920s there were many mobile businesses. Goroda's vegetable vending van honked to announce his presence. There was also the "saw guy" who drove around and cut cords of wood that the kids would stack. The school was the center of social life, and she fondly remembers Halloween parties there.

One person who should not go unmentioned is Thelma Diggs, a longtime resident and Woodlawn Neighborhood Association volunteer and board member. Thelma was hired to work part-time as the project coordinator for the WISE project and has helped with the garden, putting on the Easter egg hunt, and has led the Foot Patrol over the last few years. A picture of her appears later with the Foot Patrol.

This photograph shows the Three Boys Market, purveyors of overstock goods and incredible bargains. The bus parked momentarily in front of the store runs every 10 minutes in rush hours and every 15 minutes regularly. Bus service to Woodlawn is excellent. Two bus lines go down Dekum Street to Martin Luther King Jr. Boulevard. Please also note the strange looking sign above the bus (seen also on page 80).

Woodlawn is experiencing (as are most neighborhoods in the United States) an upsurge in graffiti. The image drawn on the building covers some graffiti underneath. It will not be there when the renovations are finished.

Seven

WOODLAWN BUSINESSES TODAY

Catfish Freeman's is one of many businesses to inhabit the building shown on the bottom of the previous page. It has been four kinds of restaurants and two versions of storefront churches. Now it is being remodeled and upgraded to become the Believe Movement Studio, a health center offering many activities such as yoga, tai chi, Pilates, and other classes. Being between a pizza parlor and Italian restaurant, it will have its clientele at its very doorsteps.

The Three Boys Market pictured on the top of page 78 used to be a Rexall Drug Store with a sideline business of veterinary prescriptions. This image shows the sign on its storefront up close. Since there were both a dog and a horse track within a few miles of Woodlawn, the veterinary pharmacy was quite popular with those who cared for racing dogs and horses.

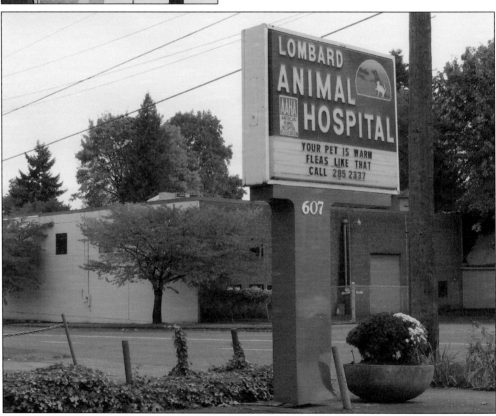

The Lombard Animal Hospital does not treat horses but it does treat dogs and cats. The train rumbles by with tracks behind the clinic, down a steep embankment on the level flood plain.

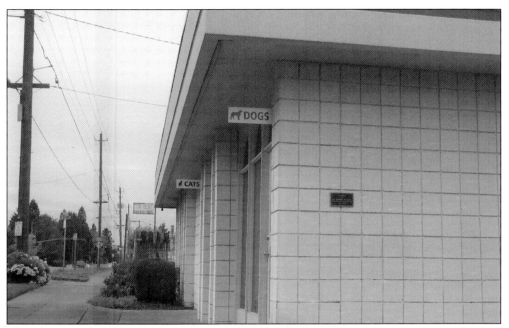

This photograph of the Lombard Animal Hospital illustrates the separate entrances for dogs and cats, which is a brilliant peace-keeping decision. The plaque on the side of the building commemorates Dr. Andrew V. Mach who first opened the clinic.

A few blocks farther east on Lombard Street reveals the Custom Marble Company, a local, independently owned company that specializes in cultured marble, granite, and onyx for sinks, baths, and so forth.

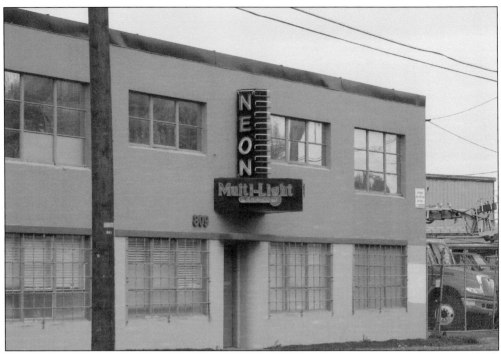

This image shows the Multi-Light Neon Company, maker and repairer of signs since 1936, which is immediately to the east of Custom Marble.

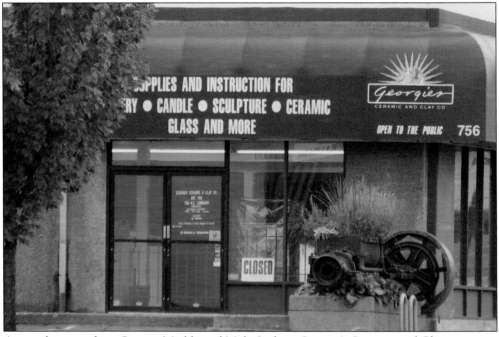

Across the street from Custom Marble and Multi-Light is Georgie's Ceramic and Clay company, which holds potting and ceramic classes. They run a co-op workshop where people can buy time to work in their fully equipped pottery studio. Unfortunately, many Woodlawn residents have no idea this business is so close. The businesses below the bluff are often driven by and not driven to.

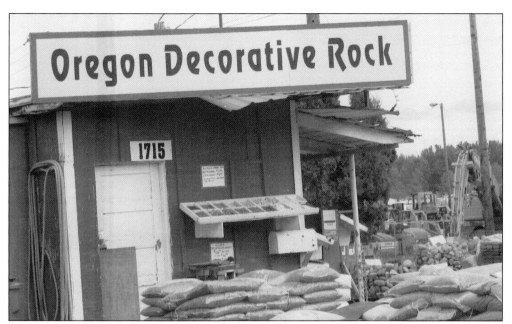

The Oregon Decorative Rock shop can be found on Columbia Boulevard where there is a large selection of beautiful stones. Buying rocks by the pound, however, is not cheap, unless purchasing the special large pumiceous ones that weigh very little.

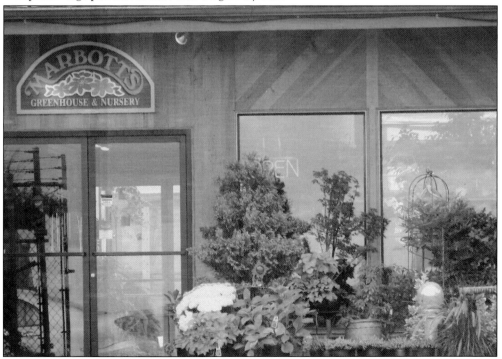

Looking to the right while heading east on Columbia Boulevard will reveal seemingly acres of greenhouses. This is Marbott's Greenhouse and Nursery. Sandwiched between train tracks and a thoroughfare, this place is an oasis of all kinds of plants located indoors, outdoors, under glass, and underfoot. Marbott's is wonderful for those who love plants.

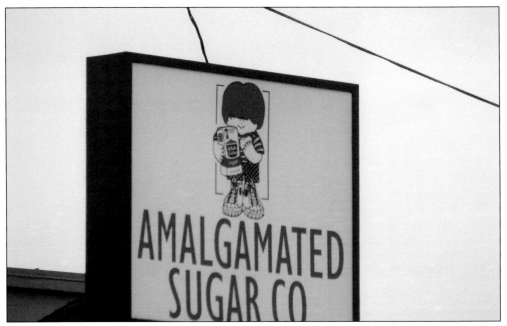

This image shows the sugar company sign. At one time, a resident who lived across Lombard Street from Amalgamated Sugar contacted the Woodlawn Neighborhood Association. This resident complained that sugar dust drifted into his house and wondered if the association could do anything to rectify this problem. The association told him that it had no solution.

The bridge over Lombard Street was recently rebuilt and was raised three inches to accommodate a repaving that raised the road three inches. Hilda Erickson (Martha Burnett's aunt) remembers the Mays Fruit Stand on Columbia Boulevard that was closed when the Japanese family who ran the stand was sent to the internment camps. Hilda's dad worked on the trains.

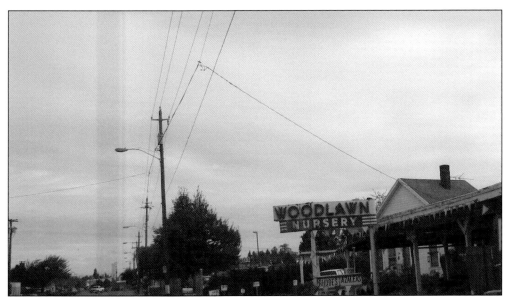

West on Martin Luther King Jr. Boulevard from Columbia Boulevard shows the Woodlawn Nursery on the left. Several years ago, the business was using a peculiar species of duck as part of its slug control program. These runner ducks were also smart enough to not run into the traffic.

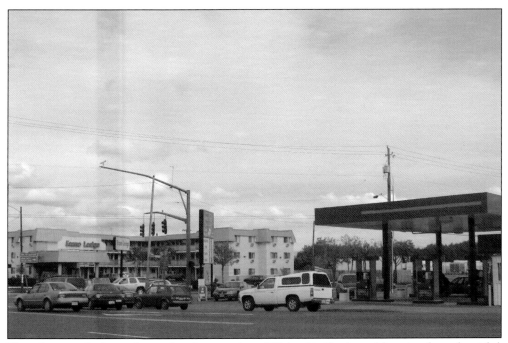

This photograph shows the modern intersection of Columbia Boulevard (coming from the right) with Martin Luther King Jr. Boulevard looking north. Compare this to the next image. This intersection is at the northwest corner of the Woodlawn neighborhood. This intersection has a very industrial look and feel, down off the bluff and in the flood plain.

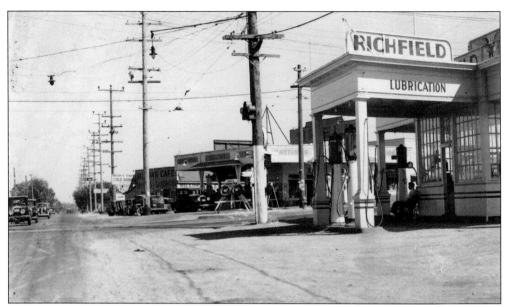

Though this image was taken during the Depression, Dillon's Café at the center of the photograph has cars parked bumper to bumper. The photographer is standing on Northeast Columbia Boulevard at the intersection of Martin Luther King Jr. Boulevard looking east. (Courtesy SPARC.)

Ainsworth Street and Martin Luther King Jr. Boulevard are in the southeast corner of Woodlawn. Technically within Woodlawn is the Walgreen's Pharmacy, which met with the Woodlawn neighborhood before building. The community asked it to post the words "Welcome to Woodlawn Neighborhood," and instead the sign was posted on the pillar as shown. It is interesting what the lack of the word "to" does to the meaning of the sign.

Ainsworth Street has another rare resource that few people know about. The Northeast Ainsworth Linear Arboretum is unique among United States arboretums. It spans actual city blocks and is composed of street and yard trees. The Northeast Ainsworth Linear Arboretum makes it possible for residents to view 57 different species of city trees within walking or bicycling distance of each other. For the details, see www.friendsoftrees.org/tree_resources/arboretum.php

In 2006 Woodlawn volunteers, organized by Paul Cone, joined Vernon and Concordia volunteers, and helped Friends of Trees plant more trees in Woodlawn and this linear arboretum. Jim Gersbach, as seen in this photograph, conceived the idea of the linear arboretum but said he found instant enthusiasm from veteran tree-planting organizers Paul Cone of Woodlawn and James Rishky from Vernon. (Courtesy Chijo Takeda.)

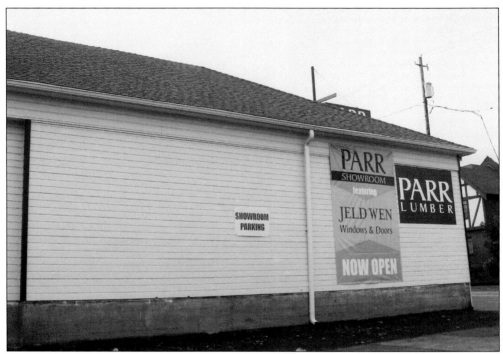

This is the Holman Street side of Parr Lumber and the far side is bordered by Ashley Street, which is rumored to be the shortest street in Portland. Mr. and Mrs. Ashley owned about an acre near the corner of Grand Avenue and Ainsworth Street. Ashley Street was named after them when they subdivided their acre and created a two block–long street as access to their property.

This slanted view of the Henry V Company reflects the slope on which it was built. The site of the former Martinson Foods Company, it has been transformed into a Leadership in Energy and Environmental Design (LEED) silver-certified business. This slope has been planted in terraces, and the plants act as bioswales to filter rain water that is captured on the roof and piped to run down an artistic chain-link fence near the entrance.

This photograph shows what used to be a grocery store at the intersection of Northeast Thirteenth Avenue and Dekum Street that caused all sorts of problems during the 1990s. The neighbors were greatly relieved when Sylvia's Corner restaurant opened there. Sylvia's supported the Woodlawn Neighborhood Association by allowing them to meet (and eat) there many times.

Health concerns caused Sylvia to hand operations over to new managers who have renamed it Izogies Fine Dining. Southern food, hamburgers, catfish, and seafood stews are among the offerings. Barbeque is cooked by Jewel Thomas, who made his name at another barbecue restaurant.

This photograph shows the local Kingdom Hall of Jehovah's Witnesses right next door to Grigsby Brothers Paper Box company.

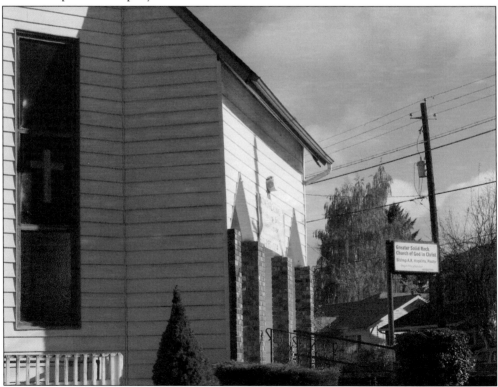

This is the Greater Solid Rock Church of God in Christ, located two blocks east of Northeast Fifteenth Avenue fronting on Dekum Street. Their choirs often sang at Woodlawn events.

Eight

THE WOODLAWN PLANS

The Albina and Woodlawn Plan process started in 1991. The hatch-marked neighborhoods to the north of Woodlawn are down in the floodplain and were indeed covered during the Vanport Flood. That dark zone to the upper left in the otherwise hatch-marked area is a large part of where Vanport city was (named because it was between Vancouver and Portland). Almost 25,000 people lived there. Ted Hoff's says, "I was shocked. Just ahead, Union Avenue simply disappeared under a huge, dirty, swirling lake that stretched for miles to the north. . . . Clumps of people had mounted the roofs and sat astride buildings that now looked like huge square rocking horses. The smaller homes were completely submerged or had been torn loose from their foundations and were slowly rolling over like giant orange crates."

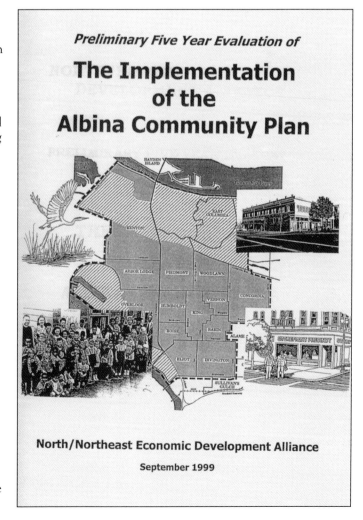

Preliminary Five Year Evaluation of

The Implementation of the Albina Community Plan

North/Northeast Economic Development Alliance

September 1999

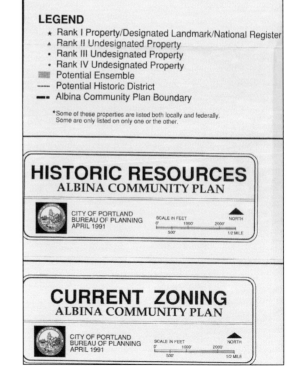

Each neighborhood was assigned a professional planner and was asked to develop a vision, a description of what the neighborhood was now, and a list of improvements to strive for. Surprisingly there have been more businesses built and revitalized along Dekum Street than multifamily residences. This is an example of the zoning that had been planned for Martin Luther King Jr. Boulevard.

A nice complication to the planning was the number of historic homes and resources. Here is the legend to the following map.

This map shows the historic design guideline district drawn around the angled streets of Woodlawn and around the Queen Anne and other historic homes and buildings. Interestingly the Portland International Airport, five miles from Woodlawn, is interested in Woodlawn as a potential runway extension area. Some Woodlawn zoning maps show that Woodlawn Park and the surrounding neighborhood might be part of that expansion decades in the future. Use the legend below to interpret the following image at the top of page 94.

The neighborhood has been discovered for its excellent location, and nicer, larger houses with more amenities are being built as infill houses. The dark areas in the angled streets are condominiums (called Woodland Park Condominiums, even though they abut onto Woodlawn Park) built in the 1970s and on a group of streets with houses in a planned community development by HOST (Home Ownership a Street at a Time).

This legend shows the decades when homes and buildings were built. Use this to interpret the image at the top of page 95.

This image shows how easy it is to spot the Woodlawn area because of the angled streets. It is interesting to note how much older the homes are in Woodlawn and neighboring Piedmont to the west and how new the houses are up the street to the east in Concordia.

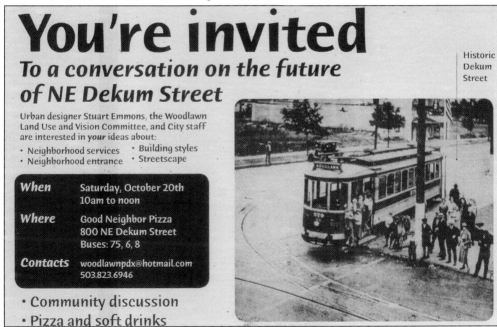

You're invited

To a conversation on the future of NE Dekum Street

Historic Dekum Street

Urban designer Stuart Emmons, the Woodlawn Land Use and Vision Committee, and City staff are interested in **your** ideas about:

- Neighborhood services
- Neighborhood entrance
- Building styles
- Streetscape

When Saturday, October 20th
10am to noon

Where Good Neighbor Pizza
800 NE Dekum Street
Buses: 75, 6, 8

Contacts woodlawnpdx@hotmail.com
503.823.6946

- Community discussion
- Pizza and soft drinks

The Woodlawn Plan Vision in 1993 was in part intended so that "on entering Woodlawn, visitors will notice the careful attention given to the placement and design of streets, parks, buildings and homes in accordance with Woodlawn Neighborhood Urban Design Guidelines. Visitors and residents will also be able to enjoy important landmarks, experience community-chosen public arts, and neighborhood activity centers."

This rose was painted in 2006 by a local artist Amy Fish. The rose, message board, and the bench were a start by members of City Repair to create gathering and information places in Woodlawn.

This bench is to the right of the rose, and behind it on the wall is a message board. Involvement by members of City Repair with the Woodlawn Neighborhood Association led to the joint proposal to host the citywide Earth Day in Woodlawn Park. City Repair is an all-volunteer, grassroots organization helping people reclaim their urban spaces to create community-oriented places.

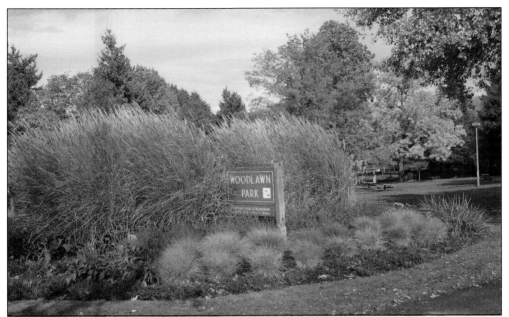

In 2004, the Woodlawn Neighborhood Association decided to focus on Woodlawn Park. At the time, the businesses on Dekum Street were not revitalized, and the park was the best asset. The residents love and maintain the park. A volunteer who lives across the street from the park maintains this planting.

This is one of the Queen Ann cherry trees remaining from the old days. The children climb up it as best they can to get to the gorgeous, non-wormy cherries.

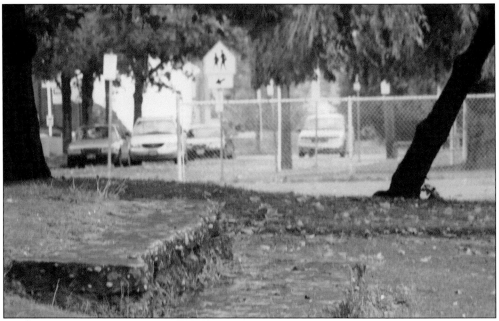

Standing with the Woodlawn Elementary School on the right and in front of the cherry tree, the softball field is visible. The field is used all spring and summer, and the seating ledges to the left of the field are made of the demolished Woodlawn and the other streets.

Pictured is an Easter egg hunt in the park. This is something that the Woodlawn Neighborhood Association has planned and done for almost 10 years. There is coffee and juice for the older folks and the Easter Bunny for children. This photograph was taken under the Claremont Street Bridge in the park. The bridge is a useful shelter in the years when it rains on the day of the Easter egg hunt. (Courtesy Thelma Diggs.)

The area for the kids is taped off, and at the appropriate signal, children dash for the eggs containing goodies. In 2007, large banners draped around the area were nearly turned into sails because of the wind. (Courtesy Thelma Diggs.)

The Woodlawn Neighborhood Association was wondering what new to do in the park. They had a multicultural fair with jazz, blues, gospel, bluegrass musicians, face painting, kids' games, hot dogs and popcorn, and many booths offering information from local non-profits, churches, city and county services. There were even clowns and belly dancers some years. This image shows a local magician at play during the fair. (Courtesy Thelma Diggs.)

This image shows that the magician has done his work and the onlookers are enthralled. Each summer there are church-sponsored youth activities, softball, baseball, and basketball. Then the Oregon Symphony came calling. As part of their outreach, each year they choose a park in which to have an outdoor summer concert, and they wanted Woodlawn to be the site in 2005. A very active planning committee created a wonderful event. (Courtesy Thelma Diggs.)

This photograph shows a neighbor grilling chicken during the multicultural fair. The park used to have enclosed areas with built-in grills, but they were not used as grills as much as they were used as meeting rooms and furniture for the gangs. The park's remodel in the late 1990s took out the grills and the enclosed areas. (Courtesy Thelma Diggs.)

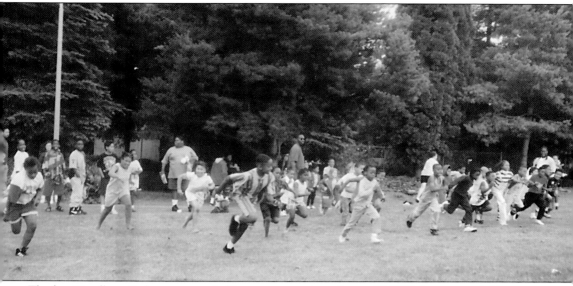

The free Woodlawn Park concert was held on a gorgeous day—August 27, 2005. It was preceded by an afternoon festival celebrating with the theme of "Back to School," including a concert of American film music and Pops favorites. The committee welcomed students and parents from recently closed Applegate Elementary, who are now attending Woodlawn Elementary. There were free haircuts for kids donated by local barbers from Woodlawn and the surrounding neighborhoods.

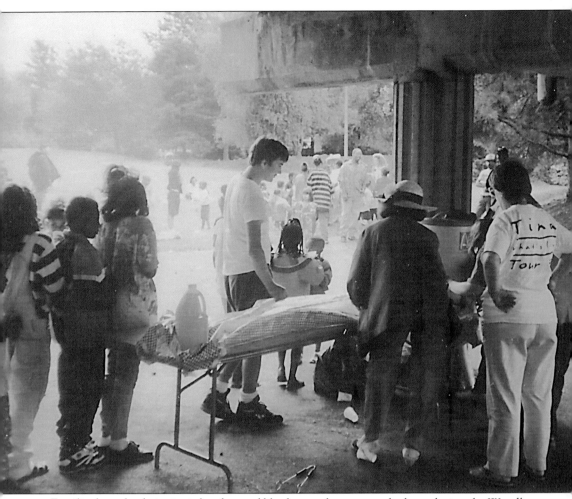

Families brought their picnic lunches and blankets and sat out on the lawn during the Woodlawn Park concert. Prior to the concert, local musicians, and groups performed. Making joyous music was the Solid Rock Gospel Choir from the Greater Solid Rock Church, an important part of the Woodlawn community for the past 35 years.

Happy with the success of the performance by the Oregon Symphony held in Woodlawn Park, City Repair was invited to host the annual Earth Day Celebration at the park. The day before the April celebration was gorgeous, with blue skies, the sun was shining, and it was warm.

This image shows that the day of the celebration was one of the most spectacularly rainy days in Portland's history. Despite that, many came from all over the city and over 150 organizations had booths around the park. Prepared for rain, the musicians played under plastic. (Courtesy Miles Hochstein, portlandground.com.)

Many types of human-powered vehicles were displayed at the celebration, and this picture shows one of the more rational-looking models. (Courtesy Miles Hochstein, portlandground.com.)

This photograph shows a demonstration of the show-biz proverb "the show must go on!" The Sprockettes precision bicycle drill team, dressed in variations of flaming pink and fishnets, braved the wet to give a fabulous show of athletic and artistic bicycling. This is one of the basketball courts resurfaced by Nike. (Courtesy Miles Hochstein, portlandground.com.)

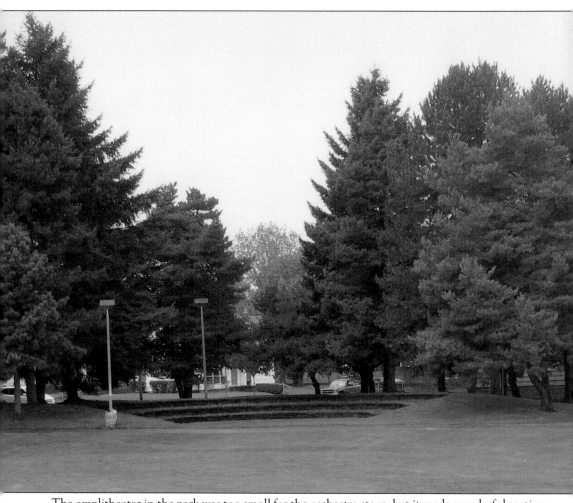

The amplitheater in the park was too small for the orchestra stage, but it made wonderful seating for audience members. In prior Woodlawn Park events, it has been used as such. Now the WNA is planning to show free movies with popcorn in the summer of 2008, with the cooperation of the Portland Parks Bureau.

Since the 1990s, the Woodlawn Foot Patrol has been a way to let neighbors know there is a Woodlawn Neighborhood Association, to strengthen the community by handing out information and referrals, and to provide a measure of additional security, by reporting things that are amiss. From left to right are Ian and Sara Gelbraith, Elvira Hudson, Thelma Diggs, Willie Ranson, and Kellie Jewett. (Courtesy of Ethan Jewett, Stickeen Photography.)

A Foot Patrol member once defused a tense neighborhood association meeting. A member of the patrol testified that she witnessed a local grocery store customer peeing in a neighbor's bushes after leaving the store. Dozens of the store's customers were at the meeting because they were asked to attend by the proprietor who feared the Woodlawn Neighborhood Association was trying to close his store down. After hearing the facts recited by a Foot Patrol member, however, one of the customers at the meeting unexpectedly apologized in front of everybody for his misbehavior. People laughed and accepted his apology. (Courtesy of Ethan Jewett, Stickeen Photography.)

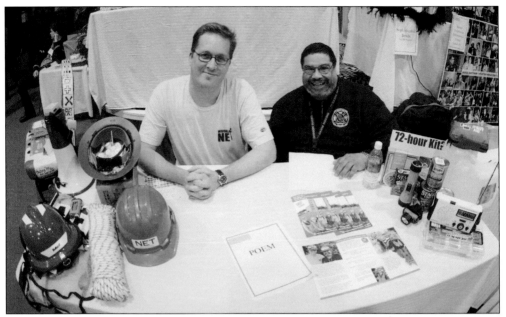

Ethan Jewett (left) and Clarence W. Harper Jr. are co-leaders of the Woodlawn Neighborhood Emergency Team (NET) and as such are often recruiting new members and informing neighbors about the resources available in an emergency. In this picture, they are manning a table at the Martin Luther King Jr. Day fair. On the table around them are the components of a personal kit that allows survival for two days. (Courtesy of Ethan Jewett, Stickeen Photography.)

This is a group shot of all the NET team participants in Fire Station 14's area that covers the Beaumont-Wilshire, Concordia, Woodlawn, Vernon, and Alameda neighborhoods. Ethan, Clarence, and Kelly Jewett (wife of Ethan and farthest right in the front of the picture) are from Woodlawn. (Courtesy of Ethan Jewett, Stickeen Photography.)

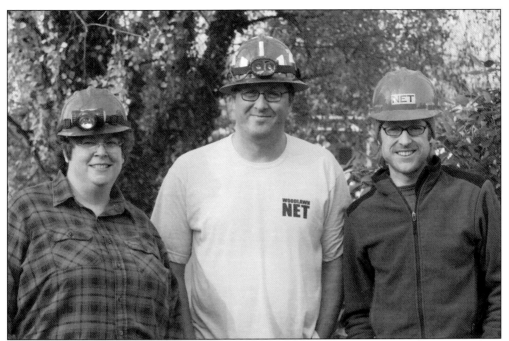

This image shows a few more members of the Woodlawn NET. From left to right are Kate MacDonald, Ethan Jewett, and Andrew Longteig. In case of a disaster, professional rescuers have to focus first on the most dangerous situations where the most people can be helped. That means neighborhoods will be on their own for a significant amount of time, perhaps days. This is why NET teams and emergency plans are being created citywide. (Courtesy of Ethan Jewett, Stickeen Photography.)

This is a picture of Jan Clutter, a former Woodlawn Neighborhood Association president, board member of the Woodlawn Community Resource Center (WCRC), coordinator of the annual Neighborhood Cleanup and Neighborhood Night Out, and proud Woodlawn NET member. The NET program aims to prepare all communities with the skills needed to be safe and effective when disaster strikes. In that case, a network of trained people can combine with untrained volunteers and serve as first responders. (Courtesy of Ethan Jewett, Stickeen Photography.)

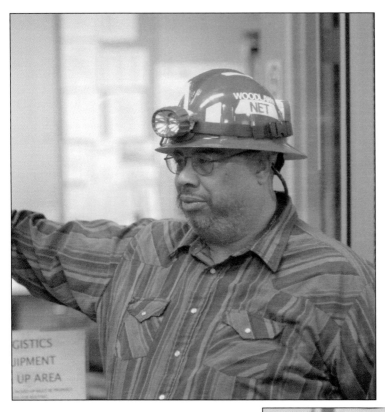

Clarence is seen here wearing his prototype NET helmet, which was selected to have a wide-brim for protection from the Portland rain. Volunteers can buy professional-grade equipment if they choose. Free training is offered to anyone over 14 years old who lives or works in Portland. Starting in 2008, the training will be offered every other month. (Courtesy of Ethan Jewett, Stickeen Photography.)

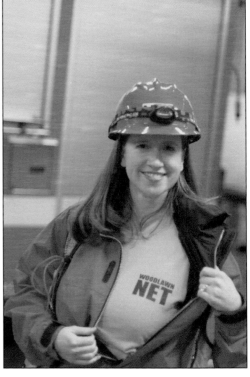

Kellie Jewett, wife of Ethan, shows off her Woodlawn NET tee shirt. This shirt was bright orange as are the helmets. The Foot Patrol vests are light yellow with darker reflective strips and dark orange lettering on a black background. The Foot Patrol walks on randomly selected days, generally after 5:00 p.m. on week nights. As the weather worsens, Foot Patrols are lessened. (Courtesy of Ethan Jewett, Stickeen Photography.)

Moulage (simulating injuries) is used for the NET training's final exercise to heighten the realism of the triage practice element. This image shows a pretty convincing fake victim of a head wound. Part of the training in disaster medicine is the recognition and treatment of life-threatening injuries and medical triage and how to decide who to treat and when. (Courtesy of Ethan Jewett, Stickeen Photography.)

This "victim" of a penetrating object seems remarkably relaxed about her situation and is waiting to be triaged. When she is triaged, however, she will play the role of victim to the hilt. The triage section is designed to give the trainees a good dose of the confusion and chaos that would happen in a real event, with screaming, dimness and or flashing lights, and simulated severe injuries. (Courtesy of Ethan Jewett, Stickeen Photography.)

This banner hangs inside the WCRC room, which does triple duty as the NET, WCRC, and WNA meeting place. The tool shown on the banner near the right as the NET symbol is the signature NET tool. It can be used to shut off gas mains and turn on other vital equipment. (Courtesy Dat Nguyen.)

The second class covers gas, electricity, and water—when to shut off and how and why. This tool is called a four-in-one-tool and it is made of a non-sparking alloy and is used to shut off gas and water valves. This photograph shows the tool being used to shut off a gas valve. The class also covers fire chemistry and extinguishers and the types and use. Controlled fires are set, and students must put them out using proper technique. (Courtesy of Ethan Jewett, Stickeen Photography.)

Classes can be taken at Portland Community College, which has sites all over Portland for convenience. Other classes are held at the fire department training facility, which is the best place for controlled fires. Here the instructor holds on to the vest of the student while they learn to extinguish the flames. (Courtesy of Ethan Jewett, Stickeen Photography.)

Kate MacDonald successfully makes a PASS with her extinguisher. PASS is an acronym for Pull the pin, Aim, Squeeze, and Sweep. If you get close enough and aim at the base of the fire, you can push the flames away from you. Part of the personal emergency kit is a face mask for use in these situations. (Courtesy of Ethan Jewett, Stickeen Photography.)

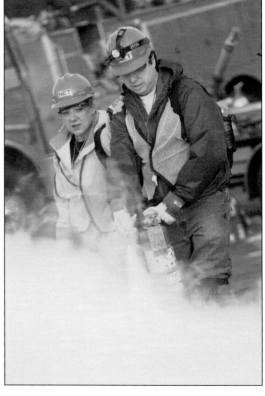

Brendan Dunn is also a Woodlawn NET member, and in this picture he is fighting fire with baking soda (many extinguishers use baking soda as their main extinguisher). The fire training familiarizes students with extinguishers with different snuffing chemicals. (Courtesy of Ethan Jewett, Stickeen Photography.)

Fire departments and fire equipment manufacturers like having volunteers try out their experimental uniform components. There is a variety of helmet configurations in the photographs. In this image, Kate MacDonald and an unidentified co-trainee are laughing in front of the rubble that will be used to pin down a dummy for extrication practice. (Courtesy of Ethan Jewett, Stickeen Photography.)

One of the skills learned is how to carefully remove people from situations where they have been pinned down by debris. The techniques are called "Cribbing and Lifting." The person kneeling in the left of the photograph is touching a dummy that has been pinned under the concrete block in the front right. (Courtesy of Ethan Jewett, Stickeen Photography.)

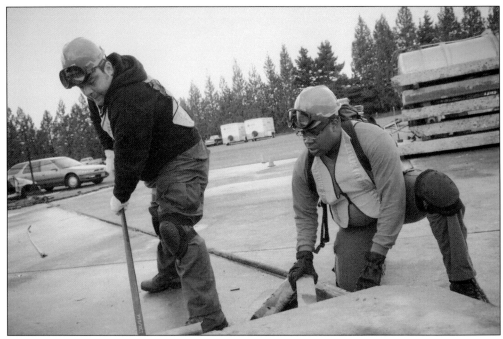

This image shows the team working together to use levers and timing to remove the dummy using approved techniques to keep the dummy victim from flopping around and potentially further being injured. (Courtesy of Ethan Jewett, Stickeen Photography.)

The unidentified student in this picture is removing the dummy. In 2007, the NET teams were part of a multimillion dollar terrorism preparation scenario. Portland and Phoenix were two cities in mainland United States, plus Guam, who hosted TOPOFF 4 on October 20, 2007. The disaster drill, whose name is short for Top Officials, tests federal, state, and local preparedness, and response capabilities to a complex terrorist attack scenario. (Courtesy of Ethan Jewett, Stickeen Photography.)

This photograph shows Brendan Dunn talking on one of the radios during a training exercise. Ideally a licensed ham radio operator in the area would go to Station 14 and set up a unit there to be the central contact person in an emergency. (Courtesy of Ethan Jewett, Stickeen Photography.)

Brendan Dunn, another NET member, is acting as field team leader in the WCRC room, which was the Situation Room. Brendan is planning routes for the four teams available through Woodlawn to reach neighbors in trouble. The teams were made up of NET members and neighborhood volunteers. The TOPOFF 4 exercise that involved Portland had a simulated dirty bomb (highly radioactive) explosion at Portland International Raceway. (Courtesy of Dat Nguyen.)

Communications and data systems are vital during crises. At the earlier exercises, (TOPOFFS 1–3) federal, state, and local agencies tested communication systems under development and even responses to cyber warfare. The radios shown here worked well during the exercise, but ham radios are the basis for the city's emergency communication plan. (Courtesy of Dat Nguyen.)

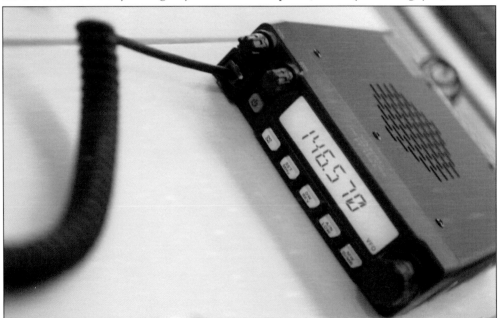

One of the failures of the exercise was the fact that the Woodlawn team was unable to establish communication with the ham radio operator at Station 14 as planned. This was exactly the kind of lesson that exercises like this are designed to develop. As a result, the city has altered its communication plan, making all NET frequencies available to team leaders and NET ham radio operators. (Courtesy of Ethan Jewett, Stickeen Photography.)

This is Martha Burnett, past Noble Grand of the Odd Fellows, past Woodlawn PTA president, Woodlawn Neighborhood Association president, Woodlawn Neighborhood Association nuisance committee chair, coauthor of the Woodlawn Plan, and server in dozens of other roles through the church and clubs. This neighborhood owes a lot to her decades of service.

This is a house that is across from Martha Burnett's house, on one of those streets that dead ends at Woodlawn Park. This house has been painted in period colors, and is mostly historically accurate with fish scale shingles and imbricated roof tiles, except for some modern additions on the far side. It was between Martha's and this house on the stub street in the 1990s where gang battles took place.

This photograph shows some modern infill houses built diagonally across Dekum Street from the Greater Solid Rock Church of God in Christ. It is interesting to note how they made an attempt to match roof lines to the angles of older houses nearby, and to give the houses adornments that match neighboring homes. Although neighborhood design guidelines recommend full porches, they created simple covered landings.

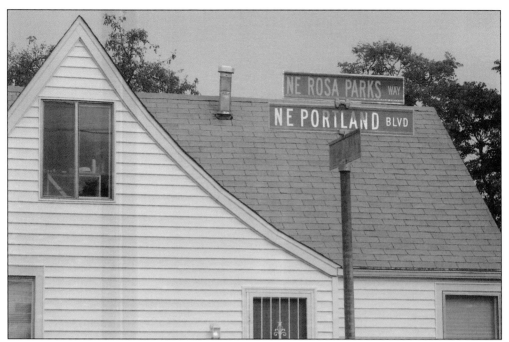

This is the house of Howard Hannon, former Woodlawn Neighborhood Association president, and co-leader of his neighborhood block watch with his neighbor to the left, Linnell Hill. Together these two men, Howard (a white, gay, former minister) and Linnell (a black longshoreman and union leader) teamed up to work with the police and shut down several drug houses. Now the street they live on is being renamed in honor of Rosa Parks.

The Moon Star Restaurant and lounge on Martin Luther King Jr. Boulevard is owned by Jack Chung, a businessman who supports the Woodlawn Neighborhood Association financially and by lending a room there to use as a meeting place for which the association is very grateful. When his clientele became too noisy for the neighbors, he worked quickly with the Woodlawn Neighborhood Association and police to remedy the situation.

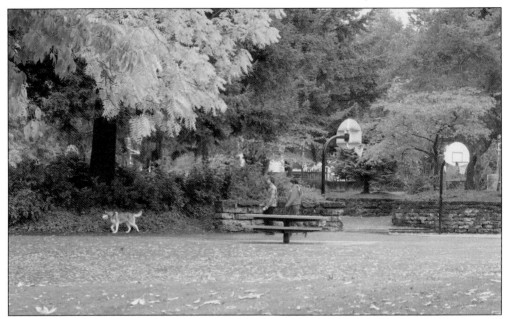

Another aspect of Woodlawn Park is that it is beloved by dog-walkers. The dog in this photograph is on a leash. The basketball court directly behind them is where the Sprockettes performed and where today's kids practice their shots, dreaming of NBA superstardom.

The story told by Martha Burnett is that a man who formerly lived in this house had the most fabulous vegetable garden. He eventually told the neighbors that he saved his urine and used it to water the plants.

This photograph looks up Stafford Street and at the right of the image you can see the cross street sloping uphill at an angle. This is an example of the styles of homes that were built during the 1960s and 1970s along the bluff edge. They have lovely views of the railroad, the sloughs and meadows beyond, and Mount St. Helens.

Down the bluff on the flat lands of Lombard Street is First Call, a heating, air conditioning, and fuel supplier. They also decommission old oil tanks. Many of the older homes may have been switched to gas or electric heat, but they still have the fuel tanks in the ground, which may leak the dregs of oil. These tanks are a consideration for homeowners when selling their houses.

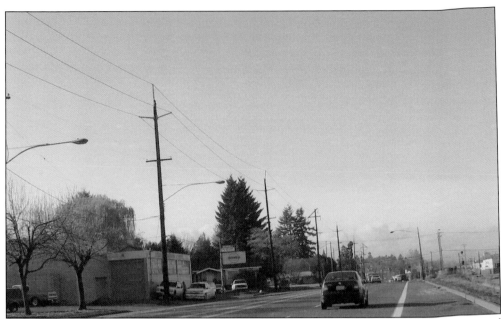

The Schnell Automotive and Supply Company at the base of Northeast Fifteenth Avenue and fronting Lombard Street provides auto repair and supplies. Northeast Fifteenth Avenue is a major street used to get to Lombard Street, and because it is relatively close to Woodlawn School (two blocks away), the Woodlawn Neighborhood Association wants to install school crossing lights and safety features atop the bluff. The Woodlawn Neighborhood Association has been working with the city's Department of Transportation.

This 1937 shot looking south on Lombard Street at the intersection of Martin Luther King Jr. Boulevard shows one of the classic, full-size billboards that are rarely found in Oregon since a law was passed greatly limiting the size and placement of billboards. One can easily imagine a motorcycle policeman lying in wait behind this billboard for anyone who speeds along. Notice there are no stop signs at this major intersection.

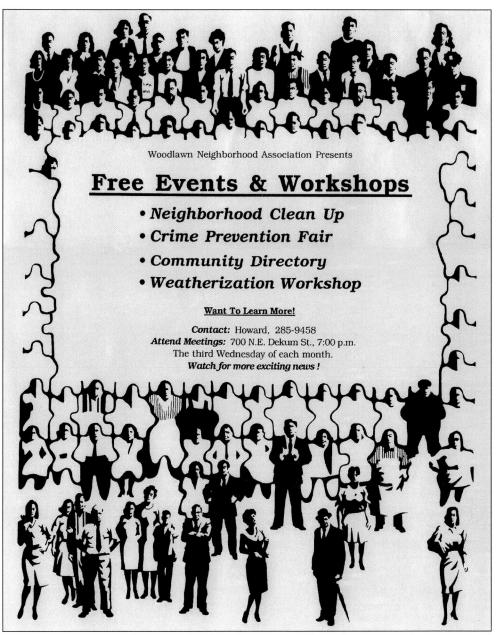

Woodlawn Neighborhood Association Presents

Free Events & Workshops

- *Neighborhood Clean Up*
- *Crime Prevention Fair*
- *Community Directory*
- *Weatherization Workshop*

Want To Learn More!

Contact: Howard, 285-9458
Attend Meetings: 700 N.E. Dekum St., 7:00 p.m.
The third Wednesday of each month.
Watch for more exciting news!

In conclusion, the Woodlawn Neighborhood Association from the 1980s to the present, and its predecessors, the Woodlawn Improvement Association in the 1970s, and the Woodlawn School PTA in the 1960s, have shown over five decades that the residents of the former Town of Woodlawn care enough for their little piece of paradise to keep working for the betterment of us all. This flyer was sent out when Howard Hannon was the Woodlawn Neighborhood Association president. Continuing volunteerism and finding and sharing resources helped progress toward accomplishing the key vision set forth in 1993. The vision stated that "in the future, Woodlawn will be a place where people live harmoniously, respectfully, and in support of one another. The neighborhood will be a clean and thriving community with beautiful homes, institutions and businesses."

BIBLIOGRAPHY

Barber, Larry. "Lewis Love: Forgotten Pioneer." *Freshwater News*. July 1985.

Piedmont: "The Emerald." Walking Tour of Historic Piedmont.

Hoff, Ted. *Why Is Your Cow in My Living Room?* Portland, OR: Variety Arts Publishing, 1987.

Hollett, George. *Woodlawn Memories*. Woodlawn E-News Newsletter, May/June 1999.

Lemley, Brad. "Beginning Defiance, Latter-day pride mark Woodlawn." *Portland Oregonian*. 18 July, 1976.

Longteig, Andrew. "A History of Woodlawn Park." *Woodlawn Voice*. Winter 2007.

Milne, Mary. "Community Profile: Martha Burnett." Woodlawn Neighborhood Association Newsletter, 1998.

Paulson, Rod. *Woodlawn—A Station on the Steam Car Line to Vancouver*. The Community Press.

Redden, Jim. "Ready for Rain." Portland, OR: *Portland Tribune*, August 28, 2007.

Woodlawn Plan. Portland, OR: Planning Bureau City of Portland, 1993.

Preliminary Five Year Evaluation of the Implementation of the Albina Community Plan, North/ Northeast Economic Development Alliance. Portland, OR: Planning Bureau, City of Portland, 1999.

Snyder, Eugene E. *Portland Names and Neighborhoods: Their Historic Origins*. Portland, OR: Binford and Mort Publishing, 1979.

INDEX

DISCOVER THOUSANDS OF LOCAL HISTORY BOOKS FEATURING MILLIONS OF VINTAGE IMAGES

Arcadia Publishing, the leading local history publisher in the United States, is committed to making history accessible and meaningful through publishing books that celebrate and preserve the heritage of America's people and places.

Find more books like this at
www.arcadiapublishing.com

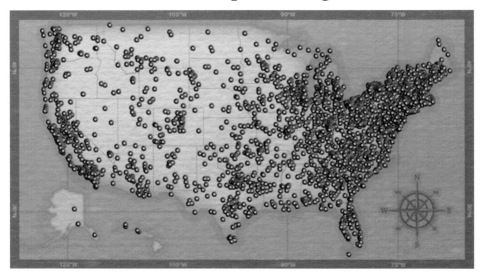

Search for your hometown history, your old stomping grounds, and even your favorite sports team.

Consistent with our mission to preserve history on a local level, this book was printed in South Carolina on American-made paper and manufactured entirely in the United States. Products carrying the accredited Forest Stewardship Council (FSC) label are printed on 100 percent FSC-certified paper.

MADE IN THE

USA